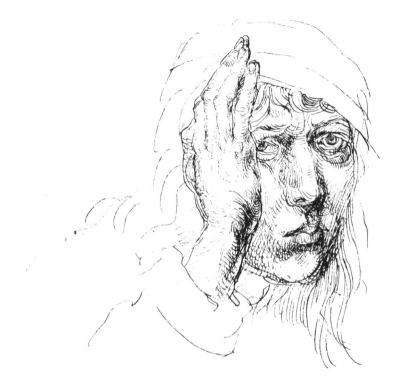

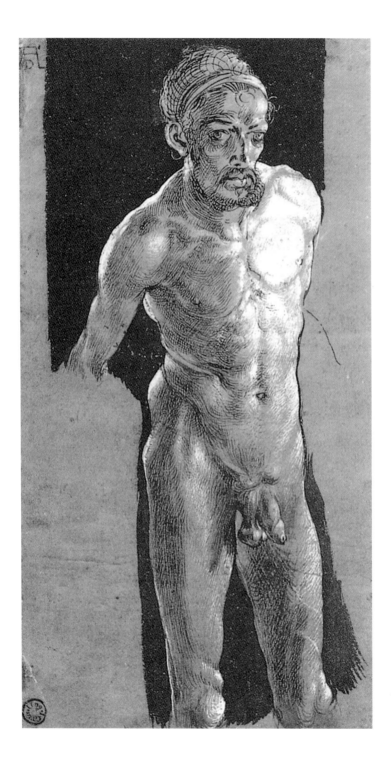

ALBRECHT DÜRER

Watercolours and Drawings

with an essay by John Berger

TASCHEN

KÖLN LONDON LOS ANGELES MADRID PARIS TOKYO

FRONT COVER:
Young Hare, 1502
Watercolour and opaque with white highlighting on paper, 25,1 x 22,6 cm
Vienna, Graphische Sammlung Albertina

BACK COVER:
Self-Portrait in a Fur Coat, 1500
Oil on limewood, 67 x 49 cm
Munich, Alte Pinakothek
(Inscribed: "Thus I, / Albrecht Dürer of Nuremberg,
have painted myself in fast paint at the age of 28 years")

PAGE 1:
Self-Portrait with a Bandage, undated
Ink drawing on paper, 20.4 x 20.8 cm
Erlangen, Graphische Sammlung der Universitätsbibliothek Erlangen-Nürnberg

PAGE 2:
Nude Self-Portrait, c. 1500
Ink and brush drawing, with white highlighting,
on green primed paper, 29.1 x 15.3 cm
Weimar, Staatliche Kunstsammlungen zu Weimar

PAGE 5:
Girl Reading (detail), 1501
Pen and dark brown ink, 16.1 x 18.2 cm
Rotterdam, Museum Boymans-van Beuningen

To stay informed about upcoming TASCHEN titles,
please request our magazine at www.taschen.com or write to
TASCHEN America, 6671 Sunset Boulevard, Suite 1508,
USA–Los Angeles, CA 90028, Fax: +1-323-463 4442.
We will be happy to send you a free copy of our magazine
which is filled with information about all of our books.

© 2004 TASCHEN GmbH
Hohenzollernring 53, D–50672 Köln
www.taschen.com

Original edition: © 1994 Benedikt Taschen Verlag GmbH
Design: Angelika Taschen, Köln
For the essay "Dürer. a portrait of the artist"
© 1985 John Berger.
© 1985 Chatto & Windus, London, for the English edition,
excluding US and Canada (from: "The White Bird")
© 1986 Random House, Inc., New York, for the US, its dependencies,
the Philippine Republic and Canada (from:"The Sense of Sight" by John Berger.
Reprinted by permission of Pantheon Books, a division of Random House, Inc.)
Photo credits: Martin Bühler, Basle (p. 26), Elke Walford, Hamburg (p. 31),
© Photo R.M.N., Paris (pp. 27, 38, 67)
Captions and biography: Klaus Ahrens, Hamburg
English translation (captions and biography): Michael Hulse, Cologne

Printed in Germany
ISBN 3-8228-8575-4

The work of Albrecht Dürer was a great summation of the achievement of art as the Middle Ages drew to a close. To this day, the mastery expressed in his precision drawing and sensuous instinct for colour has retained its fascination.

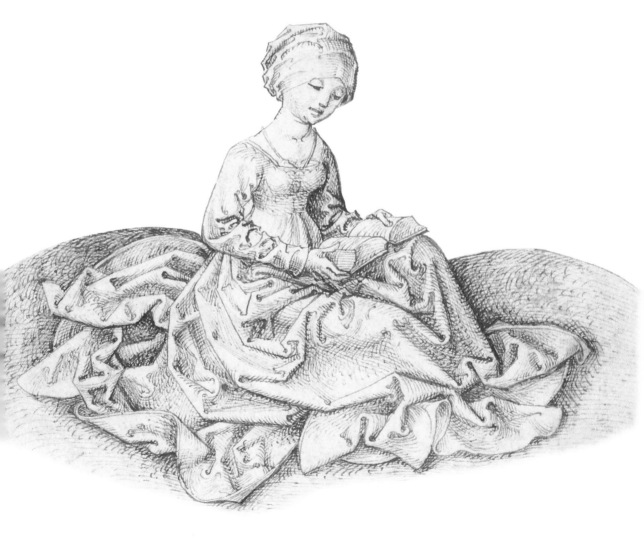

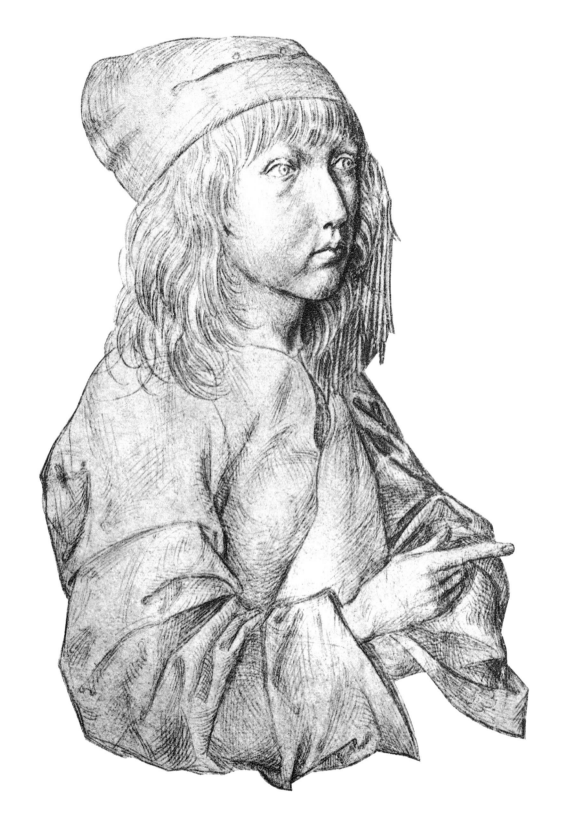

Dürer:
a portrait of the artist

Wᵉ are more than five hundred years away from Dürer's birth. (He was born on 21st May 1471, in Nuremberg.) Those five hundred years may seem long or short, according to one's viewpoint or mood. When they seem short, it appears to be possible to understand Dürer and an imaginary conversation with him becomes feasible. When they seem long the world he lived in and his consciousness of it appear so remote that no dialogue is possible.

Dürer was the first painter to be obsessed by his own image. No other before him made so many self-portraits. Among his earliest works is a silverpoint drawing of himself aged thirteen. The drawing demonstrates that he was a prodigy – and that he found his own appearance startling and unforgettable. One of the things that made it startling was probably his awareness of his own genius. All his self-portraits reveal pride. It is as though one of the elements of the masterpiece which he intends each time to create is the look of genius that he is observing in his own eyes. In this, his self-portraits are the antithesis of Rembrandt's.

Why does a man paint himself? Among many motives, one is the same as that which prompts any man to have his portrait painted. It is to produce evidence, which will probably outlive him, that he once existed. His look will remain, and the double meaning of the word "look" – signifying both his appearance and his gaze – suggests the mystery or enigma which is contained in that thought. His look interrogates us who stand before the portrait, trying to imagine the artist's life.

As I recall these two self-portraits of Dürer, one in Madrid and the other in Munich, I am aware of being – along with thousands of others – the imaginary spectator whose interest Dürer assumed about 485 years ago. Yet at the same time I ask myself how many of the words I am writing could have conveyed their present meaning to Dürer. We approach so close to his face and expression that it is hard to believe that a large part of his experience must

Self-Portrait at the Age of Thirteen, 1484. Silverpoint drawing on primed paper, 27.5 x 19.6 cm. Vienna, Graphische Sammlung Albertina. It is inscribed by the artist at top right: "Dz Hhab jch aws eim Spigell nach / mir selbs kunterfet jm 1484 Jar / do ich noch ein kint was / Albrecht Dürer".

The words mean: "My 'Konterfei' (cf. John Berger's essay, p. 12) drawn from a mirror in the year 1484, when I was still a child", and eloquently reveal the young Dürer's pride. When he drew what was in fact one of the earliest self-portraits in northern Europe, he had recently been apprenticed to his father. Dürer gave greater attention to the self-portrait than any of his contemporaries.

*Portrait of the Artist's Father,
c. 1484–1486.* Silverpoint drawing
on primed paper, 28.4 x 21.2 cm.
Vienna, Graphische Sammlung
Albertina.

The artist's father and first teacher,
Albrecht Dürer the elder, was a poor
goldsmith who had moved from
Hungary to Nuremberg, where he
had to support a family of twenty.
The young Albrecht's portrait, done
during his apprentice years, shows a
careworn, perhaps embittered man
holding a piece crafted by himself.

escape us. Placing Dürer historically is not the same thing as re-
cognizing his own experience. It seems to me important to point
this out in the face of so many complacent assumptions of con-
tinuity between his time and ours. Complacent because the more
this so-called continuity is emphasized, the more we tend, in a
strange way, to congratulate ourselves on his genius.

Two years separate the two paintings which so obviously depict
the same man in extremely different frames of mind. The second
portrait, now in the Prado Museum, Madrid, shows the painter,
aged twenty-seven, dressed like a Venetian courtier. He looks con-
fident, proud, almost princely. There is perhaps a slight over-em-
phasis on his being dressed up, suggested by, for example, his
gloved hands. The expression of his eyes is a little at odds with the
debonair cap on his head. It may be that the portrait half-confesses
that Dürer is dressing up for a part, that he aspires to a new role.
He painted the picture four years after his first visit to Italy. During
this visit he not only met Giovanni Bellini and discovered Venetian
painting; he also came to realize for the first time how inde-
pendent-minded and socially honoured painters could be. His
Venetian costume and the landscape of the Alps seen through the
window surely indicate that the painting refers back to his experi-
ence of Venice as a young man. Interpreted into absurdly crude
terms, the painting looks as though it is saying: "In Venice I took
the measure of my own worth, and here in Germany I expect this
worth to be recognized." Since his return, he had begun to receive
important commissions from Frederick the Wise, the Elector of
Saxony. Later he would work for the Emperor Maximilian.

The portrait in Munich was painted in 1500. The painting shows
the artist in a sombre coat against a dark background. The pose,
his hand which holds his coat together, the way his hair is ar-
ranged, the expression – or rather the holy lack of it – on his face
all suggest, according to the pictorial conventions of the time, a
portrait head of Christ. And although it cannot be proved,
it seems likely that Dürer intended such a comparison,
or at least that he wanted it to cross the spectator's
mind.

His intention must have been far from being blas-
phemous. He was devoutly religious and although, in
certain ways, he shared the Renaissance attitude to-
wards science and reason, his religion was of a tradi-
tional kind. Later in his life he admired Luther morally

and intellectually, but was himself incapable of breaking with the Catholic Church. The picture cannot be saying: "I see myself as Christ." It must be saying: "I aspire through the suffering I know to the imitation of Christ."

Yet, as with the other portrait, there is a theatrical element. In none of his self-portraits, apparently, could Dürer accept himself as he was. The ambition to be something other or more than himself always intervened. The only consistent record of himself he could accept was the monogram with which, unlike any previous artist, he signed almost everything he produced. When he looked at himself in the mirror he was always fascinated by the possible selves he saw there; sometimes the vision, as in the Madrid portrait, was extravagant, sometimes, as in the Munich portrait, it was full of foreboding.

What can explain the striking difference between the two paintings? In the year 1500 thousands of people in southern Germany believed that the world was just about to end. There was famine, plague and the new scourge of syphilis. The social conflicts, which were soon to lead to the Peasants' War, were intensifying. Crowds of labourers and peasants left their homes and became nomads searching for food, revenge – and salvation on the day on which the wrath of God would rain fire upon the earth, the sun would go out, and the heavens would be rolled up and put away like a manuscript.

Dürer, who throughout his whole life was preoccupied by the thought of approaching death, shared in the general terror. It was at this time that he made for a relatively wide, popular audience his first important series of woodcuts, and the theme of this series was the Apocalypse.

The style of these engravings, not to mention the urgency of their message, is a further demonstration of how far away we now are from Dürer. According to our categories, their style looks incongruously and simultaneously Gothic, Renaissance, and Baroque. We see it historically bridging a century. For Dürer, as the end of history approached and as the Renaissance dream of Beauty, such as he had dreamt in Venice, receded, the style of these woodcuts must have been as instantaneous to that moment and as natural as the sound of his own voice.

I doubt, however, whether any specific event can explain the difference between the two self-portraits. They

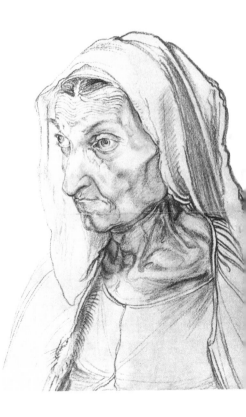

Portrait of the Artist's Mother Barbara, née Holper, undated. Charcoal drawing on paper, 42.1 x 30.3 cm. Berlin, Staatliche Museen zu Berlin – Preußischer Kulturbesitz, Kupferstichkabinett.

Dürer did this portrait of his mother shortly before she died. This study of a 62-year-old woman, on whom a life of privations in the late Middle Ages has left its marks, is one of the most penetrating portraits in the history of art.

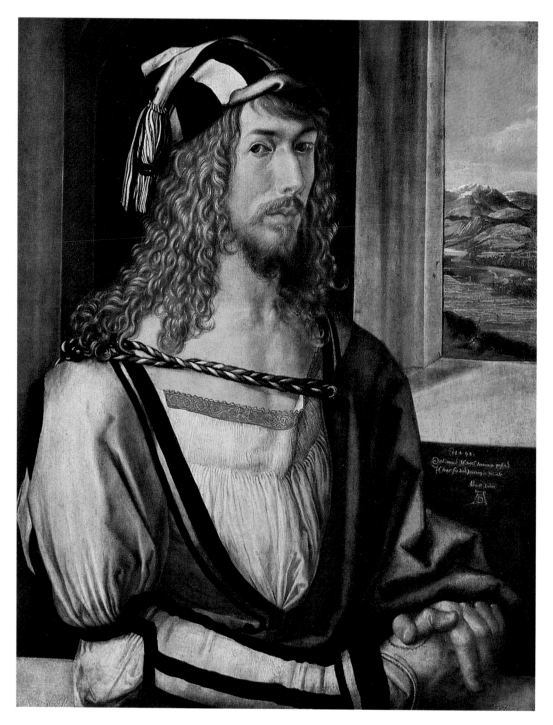

10

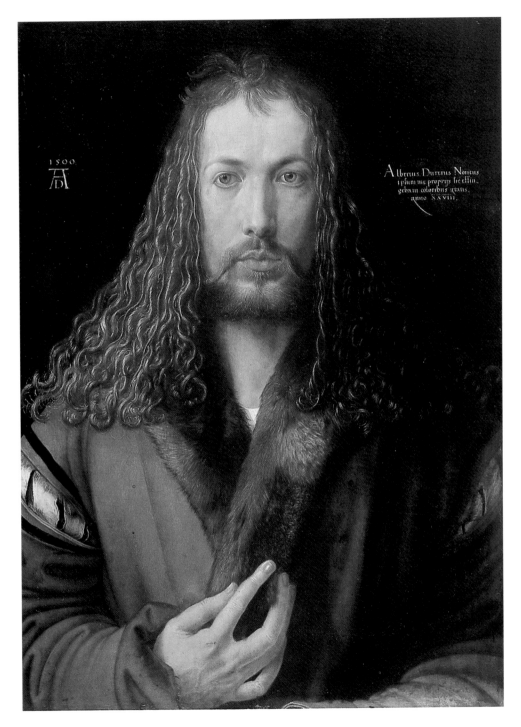

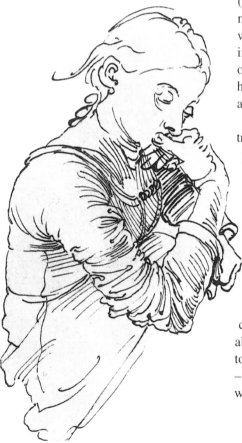

might have been painted in the same month of the same year; they are complementary to one another; together they form a kind of archway standing before Dürer's later works. They suggest the dilemma, the area of self-questioning, within which he worked as an artist.

Dürer's father was a Hungarian goldsmith who settled in the trading centre of Nuremberg. As the trade then demanded, he was a competent draughtsman and engraver. But in his attitudes and bearing he was a medieval craftsman. All he had to ask himself concerning his work was "How?" No other questions posed themselves for him.

By the time he was twenty-three years old his son had become the painter in Europe who was furthest removed from the mentality of the medieval craftsman. He believed that the artist must discover the secrets of the universe in order to achieve Beauty. The first question in terms of art – and in terms of actually travelling (he travelled whenever he could) – was "Whither?" Dürer could never have achieved this sense of independence and initiative without going to Italy. But, paradoxically, he then became more independent than any Italian painter, precisely because he was an outsider without a modern tradition – the German tradition, until he changed it, belonged to the past. He was the first, one-man, avant-garde.

It is this independence which is expressed in the Madrid portrait. The fact that he does not embrace this independence completely, that it is like a costume which he tries on, is perhaps explained by the fact that he was, after all, his father's son. His father's death in 1502 affected him greatly; he was deeply attached to him. Did he think of his difference from his father as something inevitable and ordained, or as a question of his own free choice, of which he could not be absolutely sure?

At different times probably both. The Madrid portrait includes the slight element of doubt.

His independence, combined with the manner of his art, must have given Dürer an unusual sense of power. His art came closer to recreating nature than that of any artist before him. His ability to depict an object must have seemed – as it can still seem today (think of the watercolour drawings of flowers and animals) – miraculous. He used to speak of his portraits as "Konterfei", a word which emphasizes the process of "making exactly like".

Was his way of depicting, of creating again what he saw before

him or in his dreams, in some way analogous to the process by which God was said to have created the world and all that was in it? Perhaps that question occurred to him. If so, it was not a sense of his own virtue which made him compare himself with the godhead, but his awareness of what appeared to be his own creativity. Yet despite this creativity, he was condemned to live as a man in a world full of suffering, a world against which his creative power was finally of no avail. His self-portrait as Christ is the portrait of a creator on the wrong side of creation, a creator who has played no part in creating himself.

Dürer's independence as an artist was sometimes incompatible with his half-medieval religious faith. These two self-portraits express the terms of this incompatibility. But to say this is to make a very abstract statement. We still do not enter Dürer's experience. He travelled six days once in a small boat to examine, like a scientist, the carcass of a whale. At the same time, he believed in the Horsemen of the Apocalypse. He considered Luther to be "God's instrument". How did he concretely ask, how did he really answer, as he gazed at himself in the mirror, the question which his painted face hints at as we stare into it, the question which at its simplest is: "Of what am I the instrument?"

John Berger

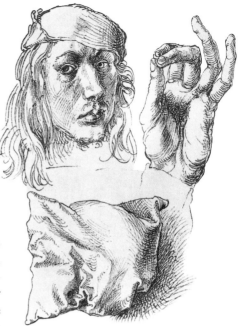

Self-Portrait, the Left Hand of the Artist, a Pillow, c. 1493. Ink drawing on paper, 27.6 x 20.2 cm. Private collection.

The three separate images of the young artist, his hand, and a pillow add up to an unusually intimate portrait. The hand contains an image of female genitals.

Opposite: *"My dear Agnes", c. 1494.* Ink drawing (bistre) on white paper, 15.6 x 9.8 cm. Vienna, Graphische Sammlung Albertina.

In 1494, after his apprentice and journeyman years, Dürer married Agnes, a bride chosen by his father, daughter of a wealthy merchant named Frey, and drew this economical portrait of her.

The Mills on the River Pegnitz, 1498. Watercolour and opaque on paper, 25.1 x 36.7 cm. Paris, Bibliothèque Nationale, Cabinet des Estampes.

Dürer frequently returned to the subject of the mills outside Nuremberg's Hall gate. This version of 1498, the year of his first great success with the Apocalypse woodcuts, is considered his most important watercolour.

Western Nuremberg, undated. Watercolour and opaque on paper, 16.3 x 34.4 cm. Lost (since 1945); formerly Bremen, Kunsthalle Bremen. (Inscribed "nörnperg" in the centre, top, with the monogram added by another hand.)

Dürer painted a great many studies of his home town, Nuremberg, but they almost invariably show the outskirts, as in this study in greens, browns and greys of the area around the Spittler gate and ditch.

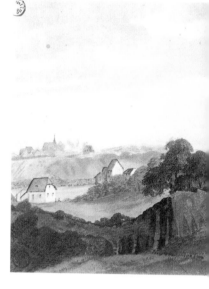

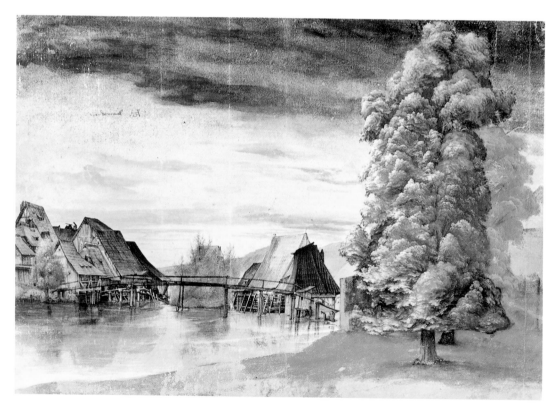

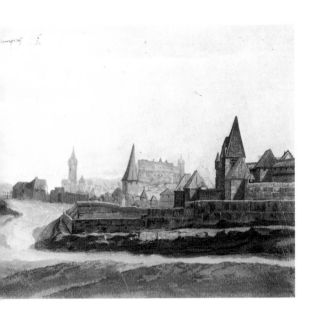

Below: *The Church and Cemetery of St. John, Nuremberg, 1494.* Watercolour and opaque on paper, 29 x 42.3 cm. Lost (since 1945); formerly Bremen, Kunsthalle Bremen.

This watercolour includes St. John's infirmary and the cemetery chapel. When the artist died in 1528, he was himself buried in this churchyard.

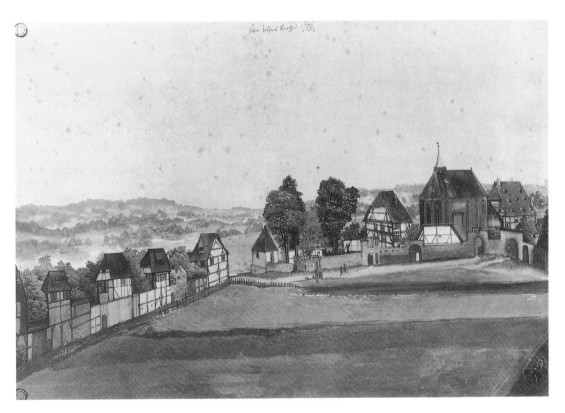

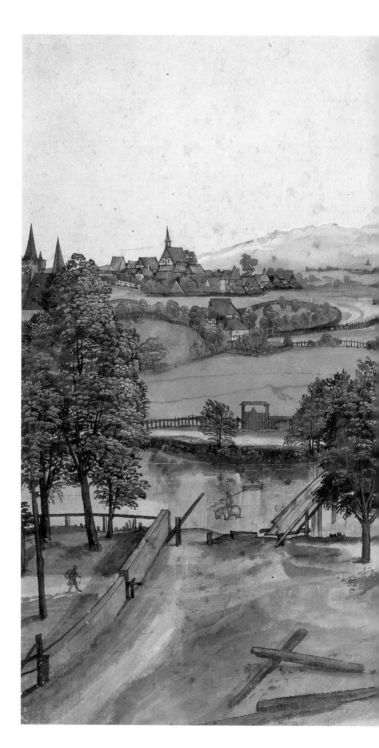

The Wire-Drawing Mill, undated.
Watercolour and opaque on paper,
28.6 x 42.2 cm. Berlin, Staatliche
Museen zu Berlin – Preußischer Kul-
turbesitz, Kupferstichkabinett. (In-
scribed: "wire-drawing mill")

This wire-drawing mill outside Nu-
remberg, and the mills on the other
bank of the Pegnitz, were the medi-
eval city's first industrial complex.
Dürer's naturalist colours here were
achieved by subtle use of wash tech-
nique, working painted areas with a
soft brush while they were still wet.
Scholars disagree on the date; some
assign the drawing to 1489/90,
others to 1494, the year Dürer re-
turned from his journeying and mar-
ried Agnes Frey.

16

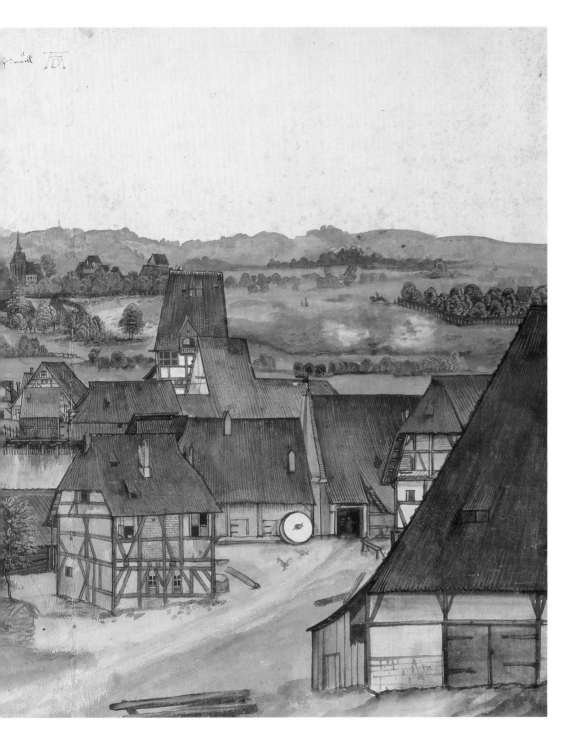

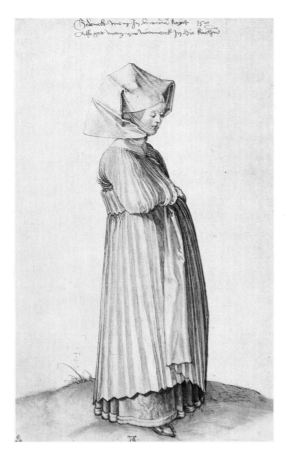

Nuremberg Woman Dressed for Church, 1500. Brush drawing touched in with watercolour, 31.7 x 17.2 cm. London, The British Museum. (Inscribed at top by Dürer: "Think of me in Thy realm 1500 / this is how people dress for church in Nuremberg")

The model was the artist's wife, Agnes.

Nuremberg Woman in Household Attire, undated. Ink drawing on paper touched in with watercolour, 28.4 x 13 cm. Milan, Biblioteca Ambrosiana.

Opposite: *Nuremberg Woman Dressed for the Dance, 1500.* Ink drawing on paper touched in with watercolour, 32.5 x 21.8 cm. Vienna, Graphische Sammlung Albertina.

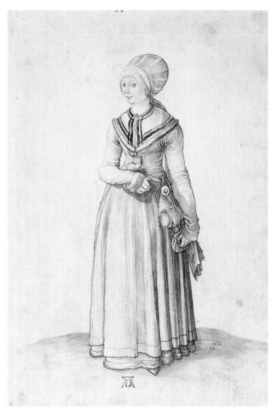

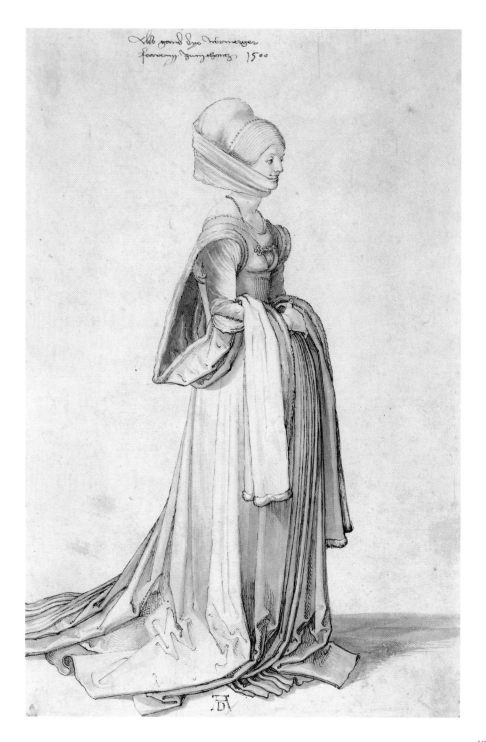

A Lake Bordered by Pine Trees, c. 1496. Watercolour and opaque on paper, 26.2 x 36.5 cm. London, The British Museum.

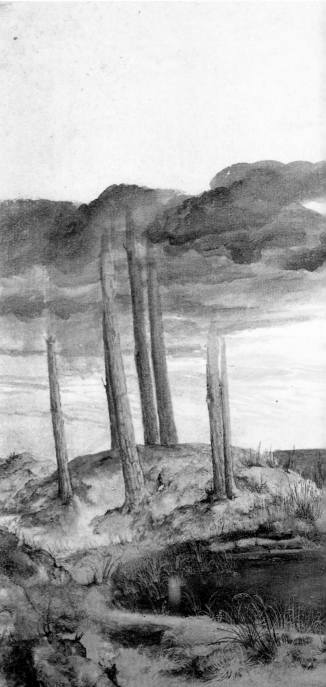

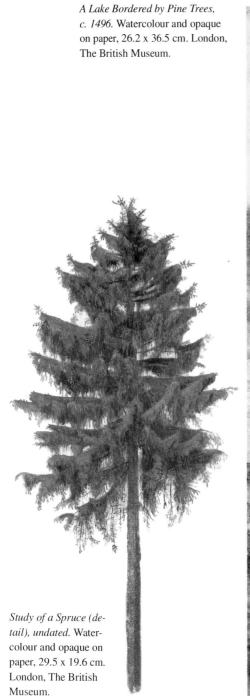

Study of a Spruce (detail), undated. Watercolour and opaque on paper, 29.5 x 19.6 cm. London, The British Museum.

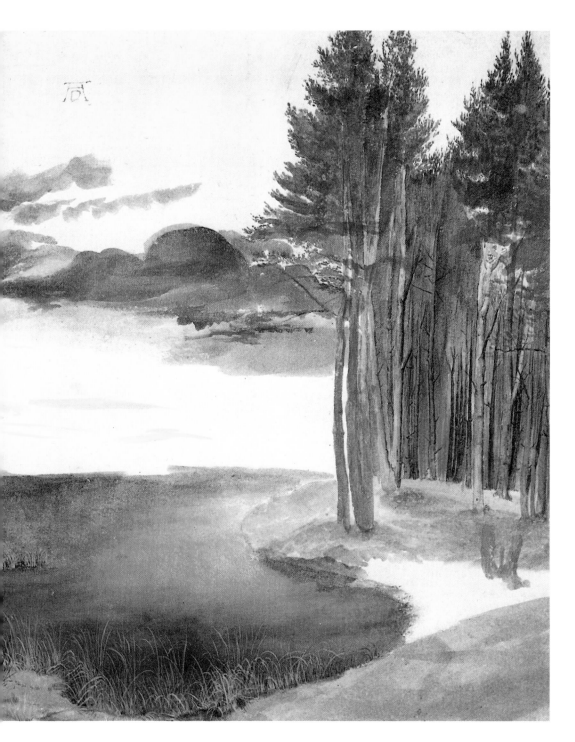

21

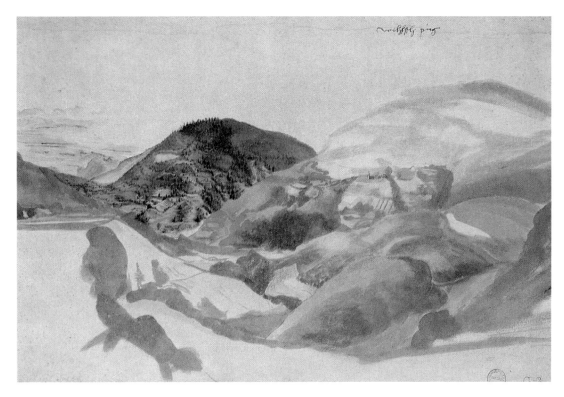

Landscape near Segonzano in the Cembra Valley, c. 1494. Watercolour on paper, 21 x 31.2 cm. Oxford, Ashmolean Museum. (Inscribed at top right: "Italian mountains")

Shortly after marrying in 1494, Dürer fled the plague for the first time, going to Italy. He took his time over the return journey, doing this muted green and blue watercolour of the mountains of the Val di Cembra, north of Trento.

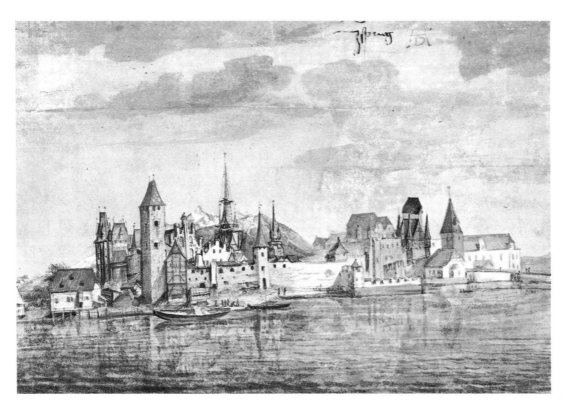

Innsbruck Seen from the North across the River Inn, undated. Watercolour on paper, 12.7 x 18.7 cm. Vienna, Graphische Sammlung Albertina.

After crossing the Brenner Pass on his return from Italy in spring 1495, Dürer paused in Innsbruck and drew the town's picturesque towers and battlements from the river side. Unusually at that date, he was clearly interested in the reflections in the water – though his success in rendering them was small. It is not, on the whole, a skilful watercolour: Dürer's perspective repeatedly gets out of control, and he changes colours and style more than once.

Page 24: *The Courtyard of Innsbruck Castle (Cloudless), undated.* Watercolour drawing on paper, 36.8 x 27 cm. Vienna, Graphische Sammlung Albertina.

Page 25: *The Courtyard of Innsbruck Castle (Cloudy), undated.* Watercolour drawing on paper, 33.5 x 26.7 cm. Vienna, Graphische Sammlung Albertina.

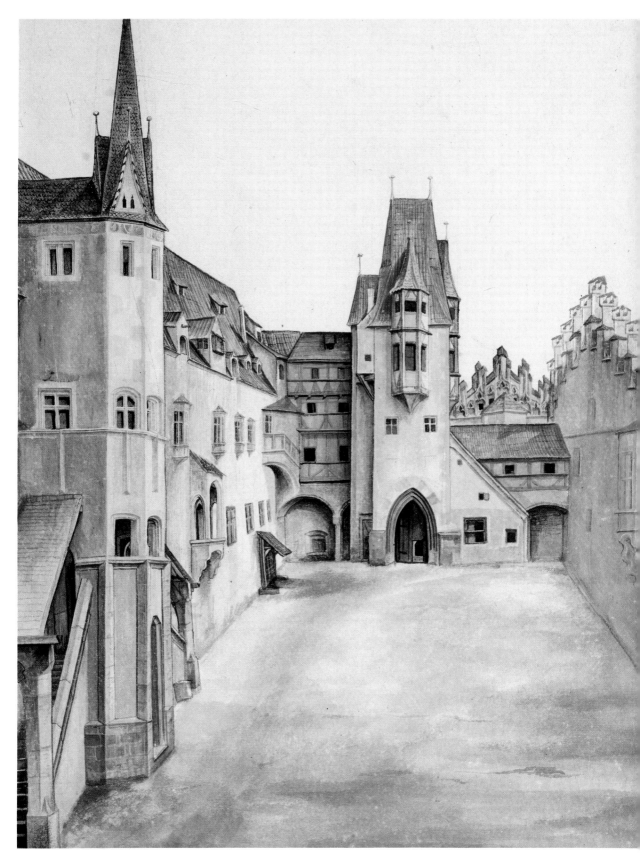

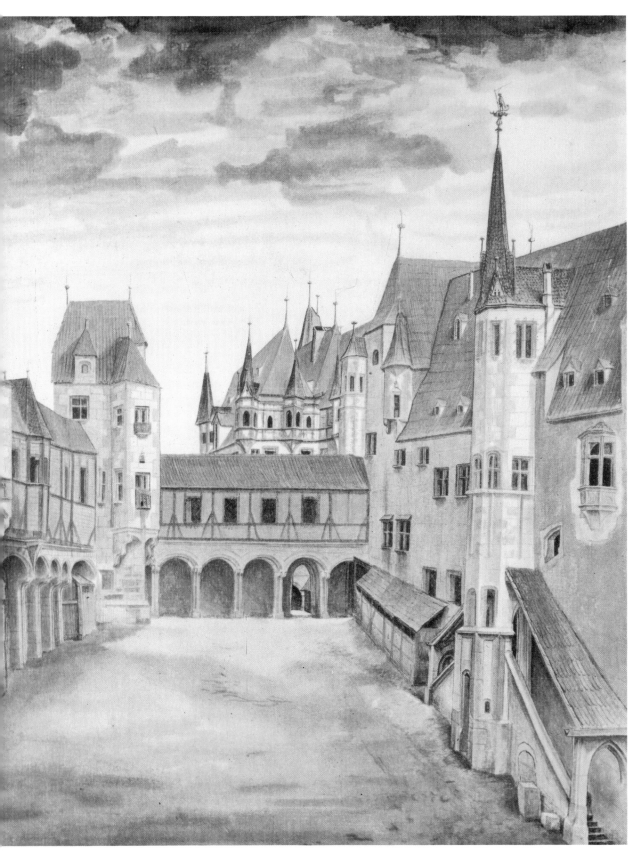

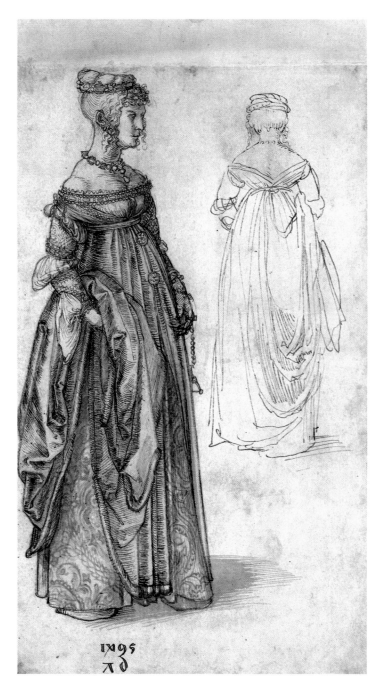

Venetian Woman, Profile and Back Views, c. 1495. Ink drawing on paper, 29 x 17.3 cm. Vienna, Graphische Sammlung Albertina.

Venice was the "Manhattan of the Old World", a bustling city of fashion and luxury. Dürer studied not only the art of his Italian fellows but also Venetian society's opulent style. His eye for every fold of the ladies' costly gowns was keen.

Nuremberg Damsel Dressed for the Dance, 1500–1501. Ink drawing on paper with watercolour, 32.4 x 21.1 cm. Basle, Öffentliche Kunstsammlung, Kupferstichkabinett.

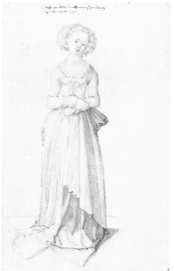

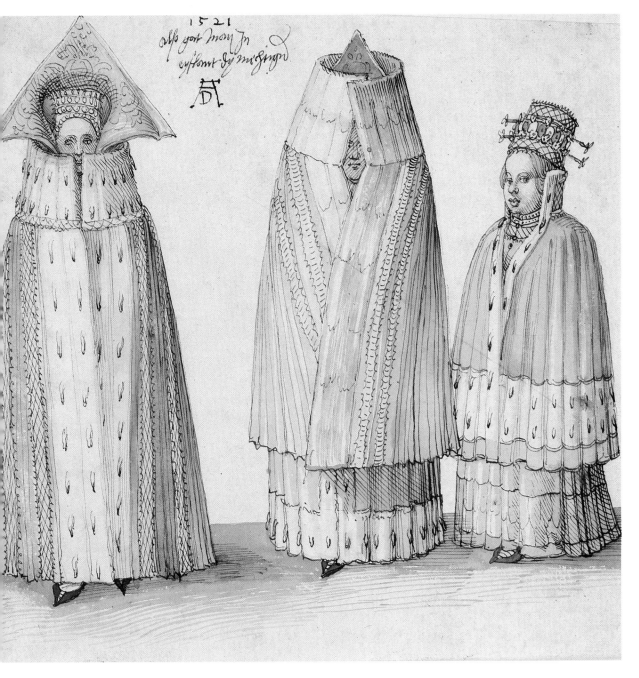

Three Livonian Women, 1521.
Watercolour and ink, 18.7 x 19.7 cm.
Paris, Musée du Louvre, E. v. Roth-
schild Collection.

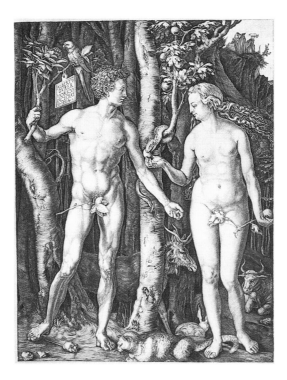

Adam and Eve, 1504. Copper engraving, 25.2 x 19.5 cm.

Adam and Eve, 1504. Ink drawing with brown wash on paper, 24.2 x 20.1 cm. New York, J. Pierpont Morgan Library.

After 1500, Dürer devoted intense labours to the ideal proportions of the human body. The drawing he made in preparation for his copper engraving of the biblical ancestors of the race was purely a study in body posture.

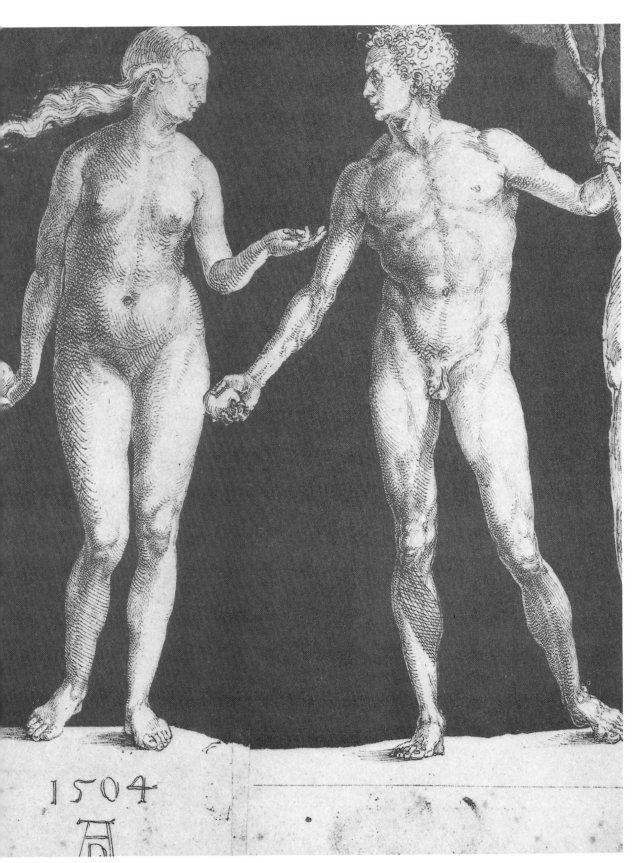

Young Couple Walking, undated.
Brown ink drawing on paper,
25.8 x 19.1 cm. Hamburg, Hamburger Kunsthalle. (Unevenly cut.)

This ink drawing, probably done in Basle, was a product of Dürer's journeyman years. Couples walking out made a popular subject in the 15th century. Dürer's realistic piece goes beyond the work of other artists working in idealistic, courtly modes, and gives the two lovers more distinctively individual features than was usual. The young man even bears a resemblance to the artist himself.

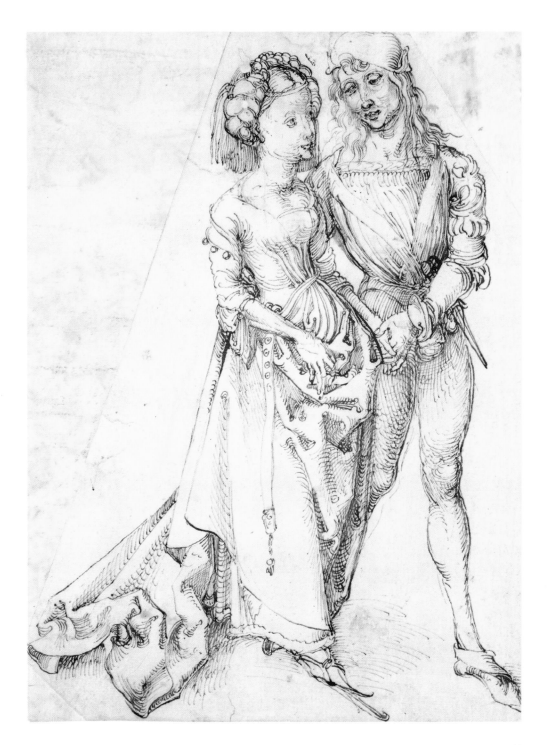

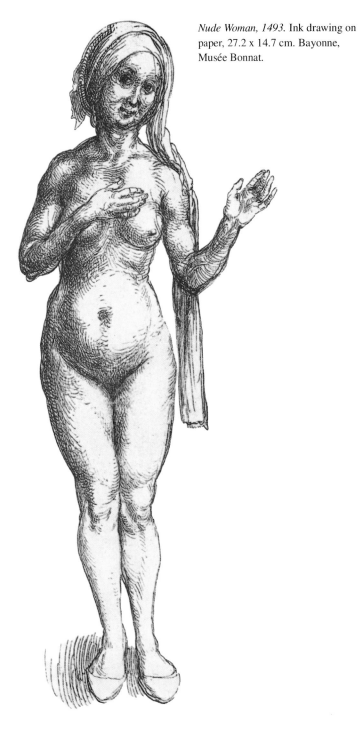

Nude Woman, 1493. Ink drawing on paper, 27.2 x 14.7 cm. Bayonne, Musée Bonnat.

Nude Woman, undated. Ink drawing, 29 x 18.8 cm. From the "Dresden sketchbook". Dresden, Sächsische Landesbibliothek.

Opposite: *The Womens' Bath, 1496.* Ink drawing on paper, 23.1 x 22.6 cm. Lost (since 1945); formerly Bremen, Kunsthalle Bremen.

The six women in the drawing represent six different ages.

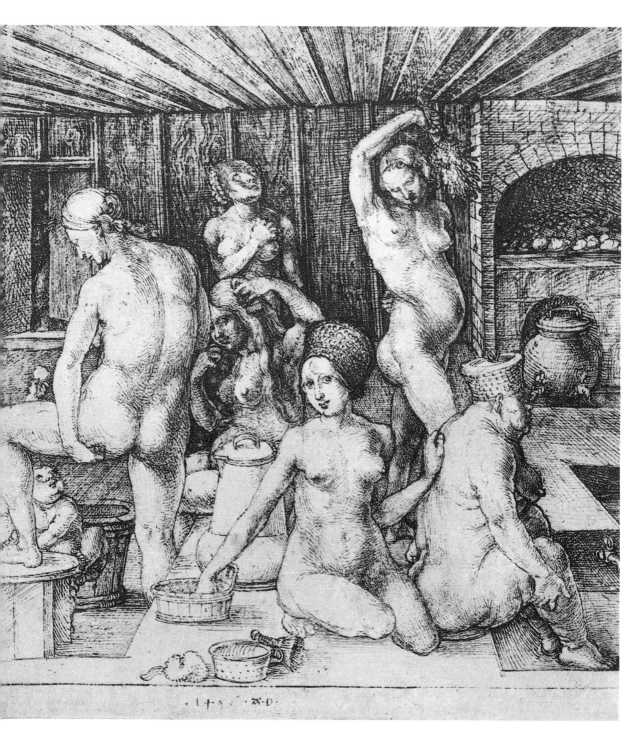

Female Nude from the Rear, 1495.
Brush drawing on paper, 32 x 21 cm.
Paris, Musée du Louvre, Cabinet des
Dessins.

Dürer tackled the nude at an early
stage, as his 1495 brush and pen
drawings show. These were the first
female nudes to be done from living
models north of the Alps.

Opposite: *Apollo, undated.* Grey-
brown ink drawing on unevenly cut
paper, 31.5 x 22.3 cm. Zurich,
Kunsthaus Zürich, Graphische
Sammlung.

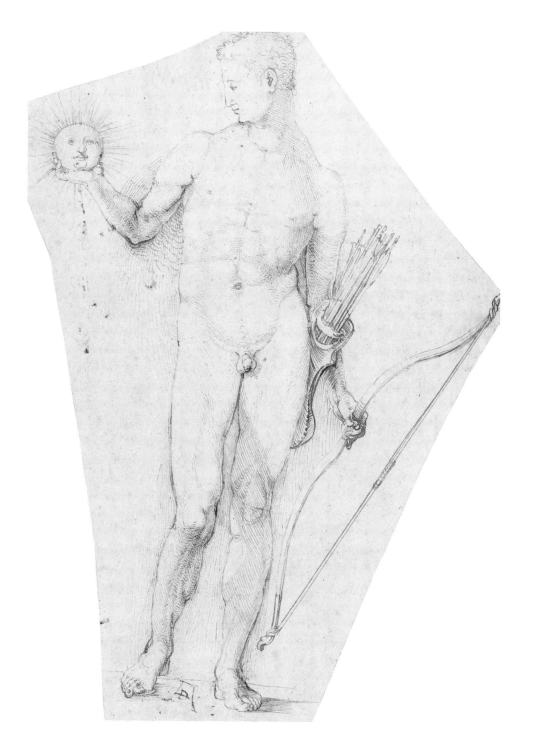

Opposite: *Six Nude Figures, 1515.*
Ink drawing, 27.1 x 21.2 cm. Frank-
furt, Städelsches Kunstinstitut.

Scenes of martyrdom, such as this
nude tied to a tree, were familiar in
the late medieval world. The world
view of the pre-Reformation Church
emphasized martyrs. Christ Himself
was tied to a stake and flogged be-
fore the crucifixion. This drawing
was no doubt a preliminary study for
some martyrdom scene, such as
Dürer's *Martyrdom of the Ten Thou-
sand (1508).*

*Nude Man with a Club (detail), un-
dated.* Ink drawing, 11.5 x 17.5 cm.
Lvov, Lubomirski Museum. (Mono-
gram added by another hand.)

36

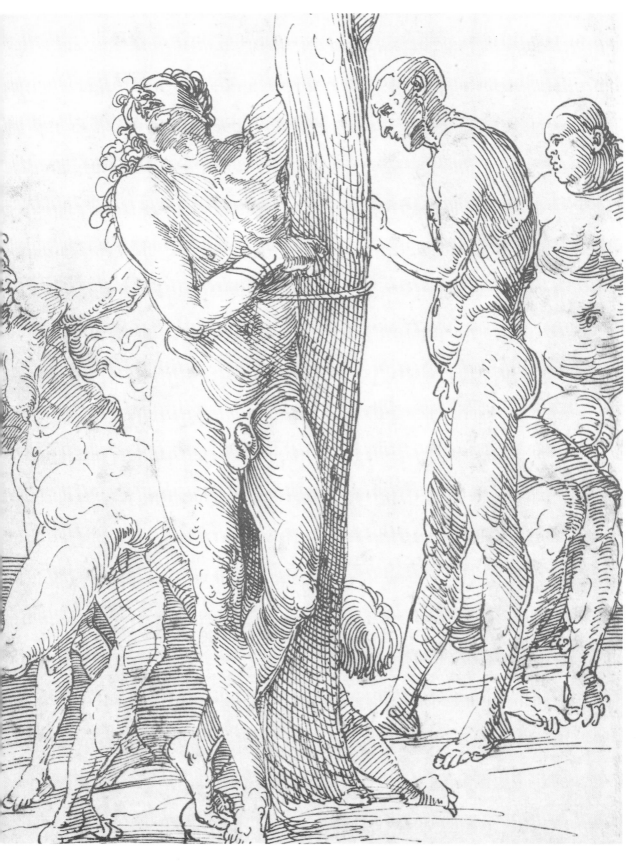

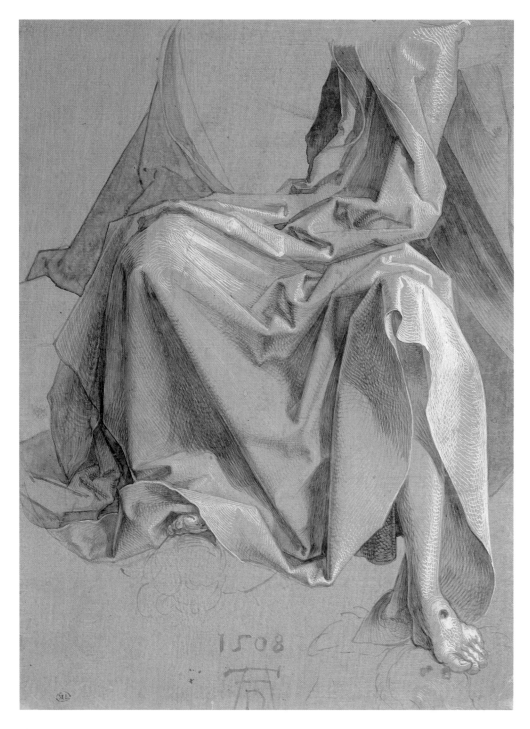

1508

Opposite: *Study for the Robes of Christ, 1508.* Brush drawing with white highlighting on green primed paper, 25.6 x 19.6 cm. Paris, Musée du Louvre. (Monogram and date by Dürer)

Another preliminary study for the Heller altar (destroyed) shows Christ's robes.

Feet of an Apostle, 1508. Ink drawing with white highlighting on green paper, 17.7 x 21.7 cm. Rotterdam, Museum Boymans-van Beuningen.

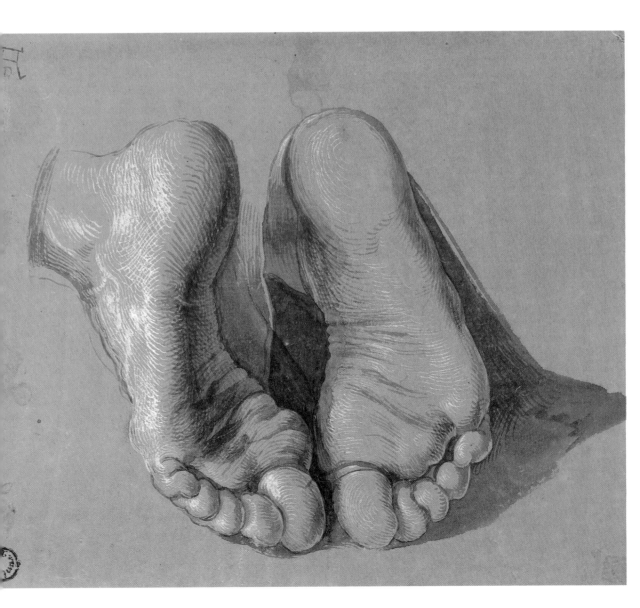

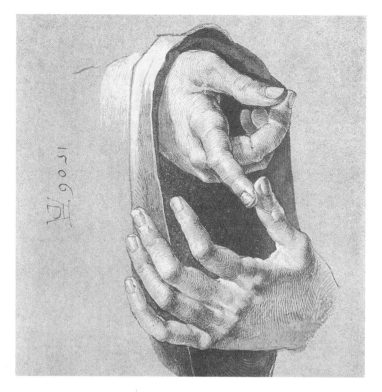

The Hands of the Twelve-Year-Old Christ, 1506. Study for the painting *The Twelve-Year-Old Christ among the Scholars.* Ink drawing with wash and white highlighting on blue Venetian paper, 20.7 x 18.5 cm. Nuremberg, Germanisches Nationalmuseum.

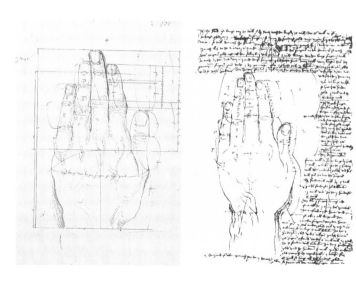

Study of the left hand, in: "Four Books of Human Proportions".

Opposite: *Study of Three Hands, 1494.* Ink drawing, 27 x 18 cm. Vienna, Graphische Sammlung Albertina.

Dürer frequently drew hands. At times he did so purely for practice, capturing gestures or movements in the process. At other times he was making preliminary studies for works such as *The Twelve-Year-Old Christ among the Scholars.* Hands were evidently of great importance to Dürer, and he analysed them closely in his "Four Books of Human Proportions".

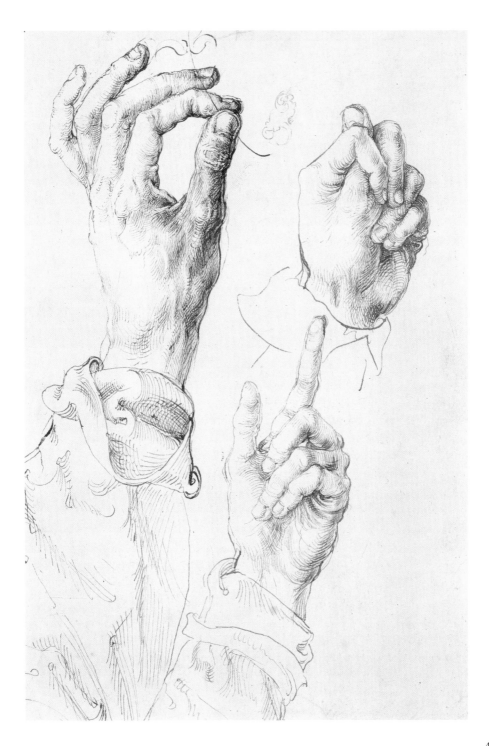

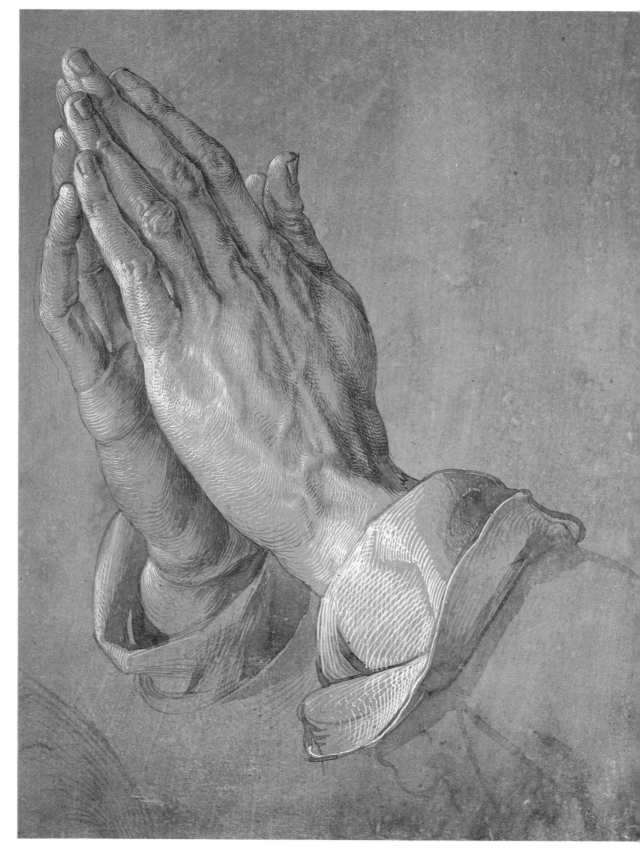

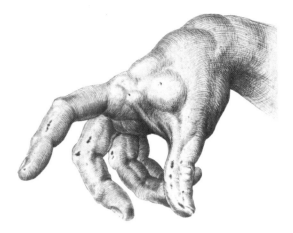

Praying Hands, 1508. Ink drawing
on blue paper, 29 x 19.7 cm. Vienna,
Graphische Sammlung Albertina.

In 1508 Dürer began work towards
the Heller altar. He did a number of
sketches, including this drawing of
hands folded in prayer, now one of
his most famous works. A later copy
shows that they were the hands of an
apostle, gathered at an empty grave
with his fellows and gazing upward
at the coronation of the Virgin Mary.

Standing Apostle, 1508. Study for
the Heller altar. Indian ink drawing
with wash and white highlighting on
green primed paper, 40.7 x 24 cm.
Berlin, Staatliche Museen zu Berlin –
Preußischer Kulturbesitz, Kupfer-
stichkabinett. (Monogram and date
by Dürer.)

For two years, 1508 and 1509, Dürer
worked on an altar commissioned by
Jakob Heller, a Frankfurt merchant.
The centre panel, depicting the coro-
nation of the Virgin, was destroyed
by a fire in the palace at Munich in
1729. All that now remains is a 17th-
century copy, and 18 brush draw-
ings. The apostle with the shep-
herd's staff is one of these prelimin-
ary studies.

Page 46: *Head of an Angel, 1506.*
Study for the painting *Adoration of
the Virgin*, or, *Feast of Rose Gar-
lands.* Brush drawing with white
highlighting on blue Venetian paper,
27 x 20.8 cm. Vienna, Graphische
Sammlung Albertina.

Page 47: *Head of the Twelve-Year-
Old Christ, undated.* Study for the
painting *The Twelve-Year-Old Christ
among the Scholars.* Ink drawing
with white highlighting on blue
Venetian paper, 27.5 x 21.1 cm.
Vienna, Graphische Sammlung Al-
bertina.

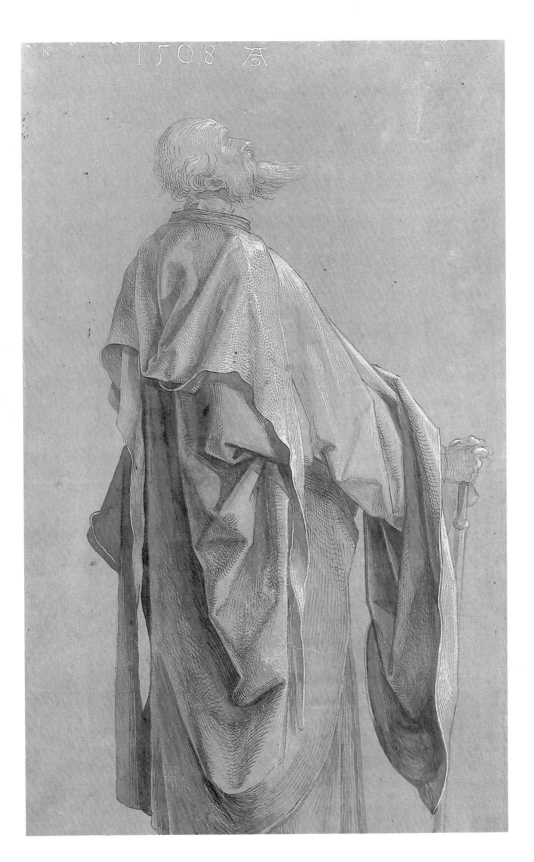

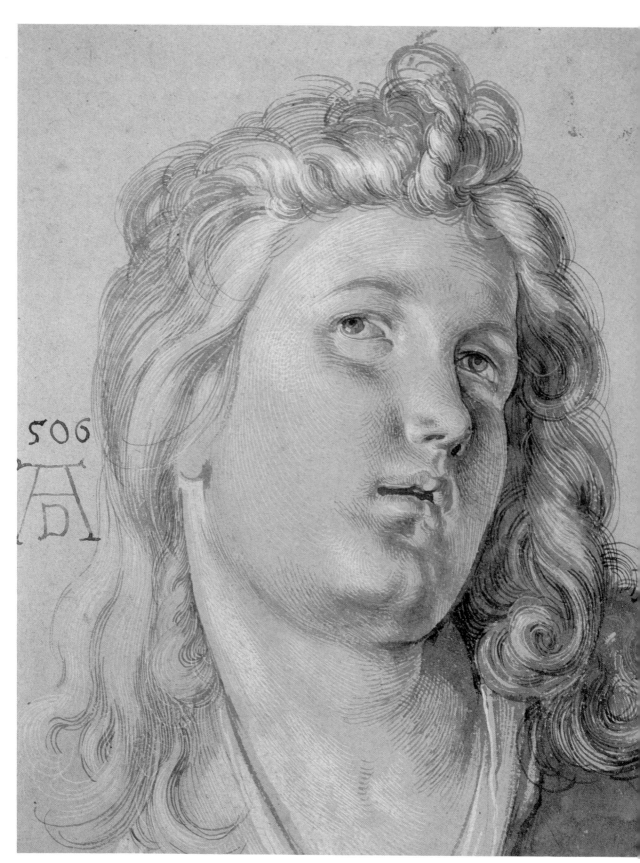

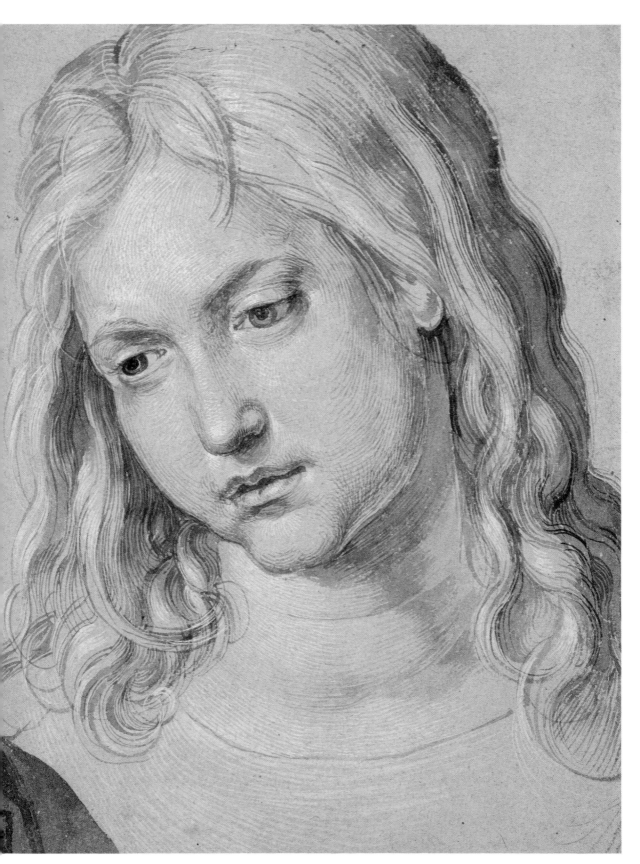

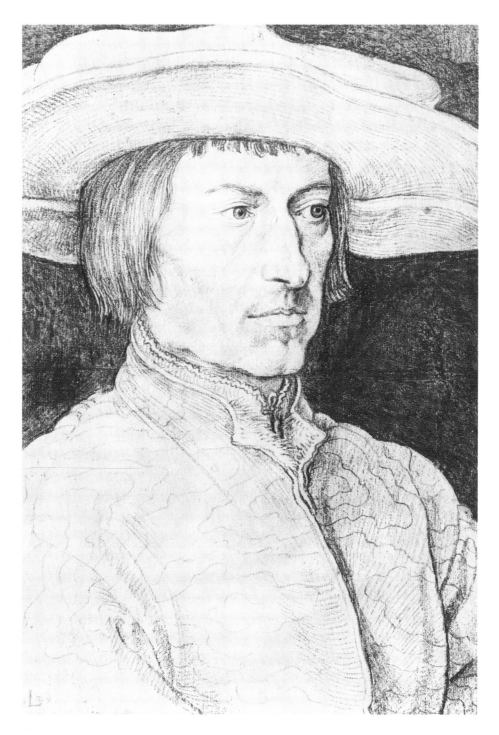

48

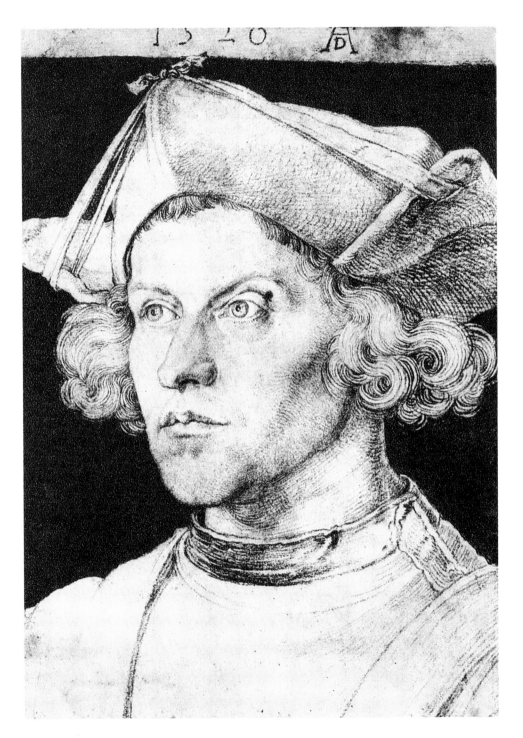

49

Page 48: *Portrait of a Man, c. 1521.*
Charcoal drawing, 36.8 x 25.5 cm.
Berlin, Staatliche Museen zu Berlin –
Preußischer Kulturbesitz, Kupfer-
stichkabinett.

Page 49: *Portrait of a Young Man,*
1520. Charcoal drawing,
36.6 x 25.8 cm. Berlin, Staatliche
Museen zu Berlin – Preußischer
Kulturbesitz, Kupferstichkabinett.
(Monogram and date by Dürer.)

Man with a Drill, c. 1496–1497. Ink
drawing, 25.1 x 15.1 cm. Bayonne,
Musée Bonnat.

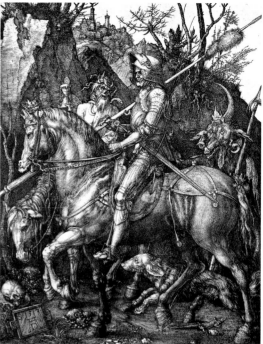

The Knight, Death and the Devil,
1513. Copper engraving,
24.4 x 18.9 cm.

This 1513 engraving of an eques-
trian Christian knight is one of
Dürer's masterpieces as engraver.
With *St. Jerome* and *Melancolia* it
constitutes the great high-point in
Dürer's graphic work.

Opposite: *Horseman, 1498.* Ink
drawing touched in with watercolour
on paper, 41.2 x 32.4 cm. Vienna,
Graphische Sammlung Albertina.

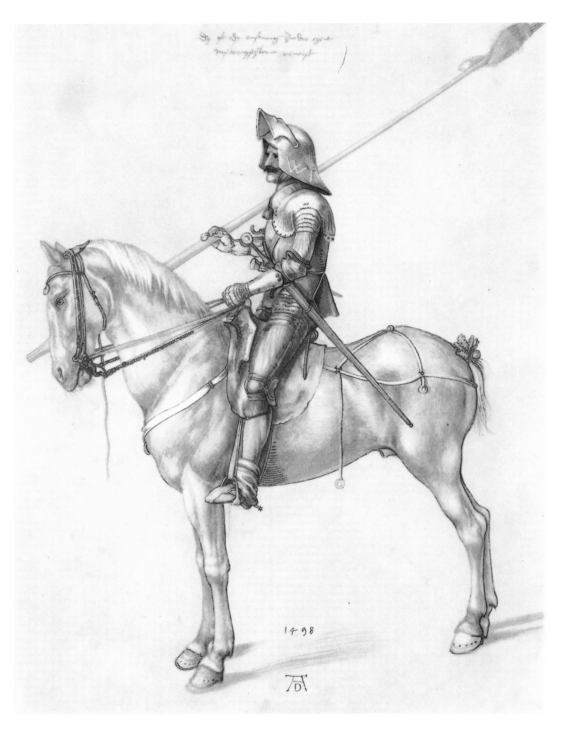

1498

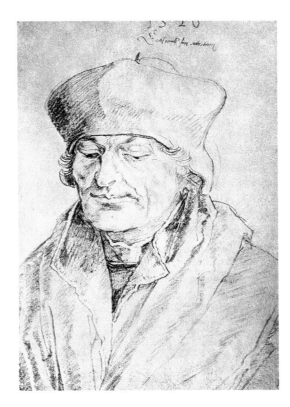

Erasmus of Rotterdam, 1520.
Charcoal drawing on paper,
37.3 x 27.1 cm. Paris, Musée du
Louvre, Cabinet des Dessins.

Dürer met the preeminent scholar on
a number of occasions. Erasmus re-
quested a portrait by Dürer, but was
extremely disappointed by the result.

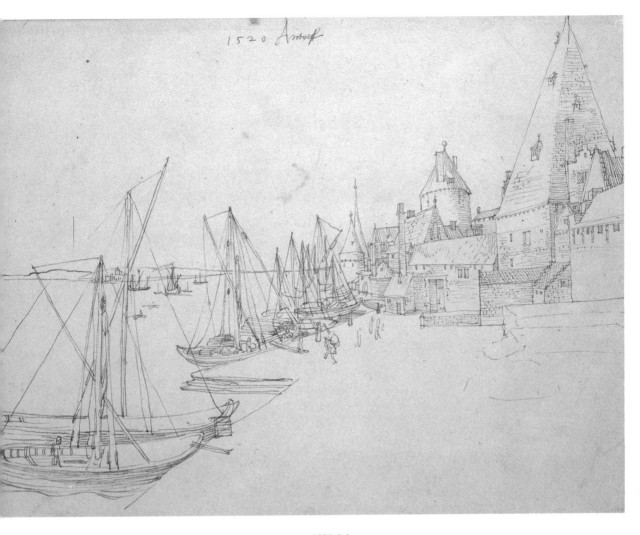

The Harbour at Antwerp, 1520. Ink
drawing, 21.3 x 28.3 cm. Vienna,
Graphische Sammlung Albertina.

This 1520 view of the prosperous
port at the mouth of the Schelde,
with its clear composition and
straightforward handling of line, is
one of Dürer's most important land-
scapes.

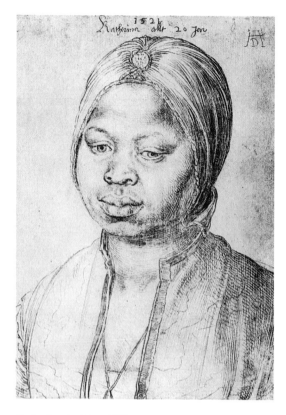

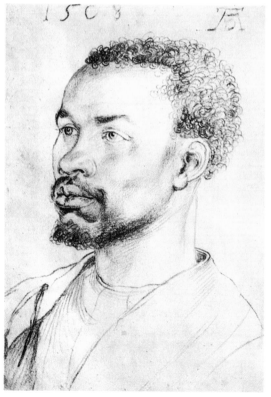

Katharina the Moor, 1521. Silverpoint drawing on paper, 20 x 14 cm. Florence, Galleria degli Uffizi, Gabinetto Disegni e Stampe.

While staying in the Antwerp home of João Brandão, a Portuguese merchant, Dürer drew this portrait of a black servant employed there, as he noted in his diary. The drawing is inscribed: "Katharina aged 20 years."

Portrait of a Negro, 1508. Charcoal drawing on paper, 32 x 21.8 cm. Vienna, Graphische Sammlung Albertina.

This portrait of a black was very probably done as a preliminary study for one of the great altars Albrecht Dürer and his studio created around 1508.

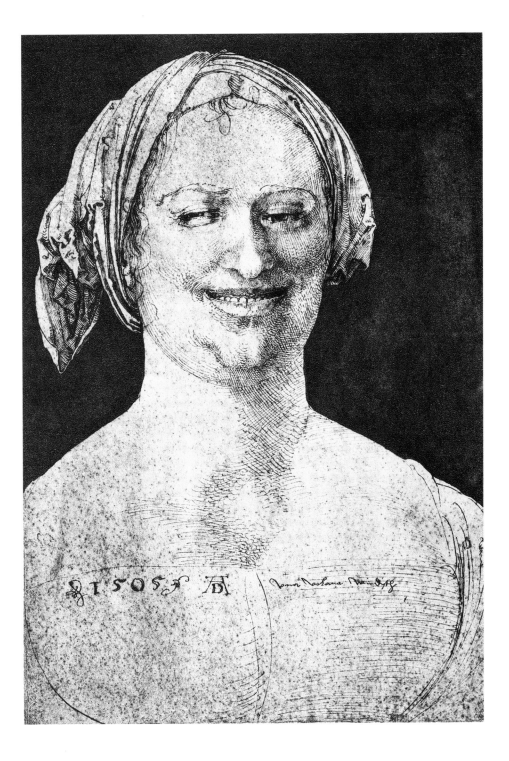

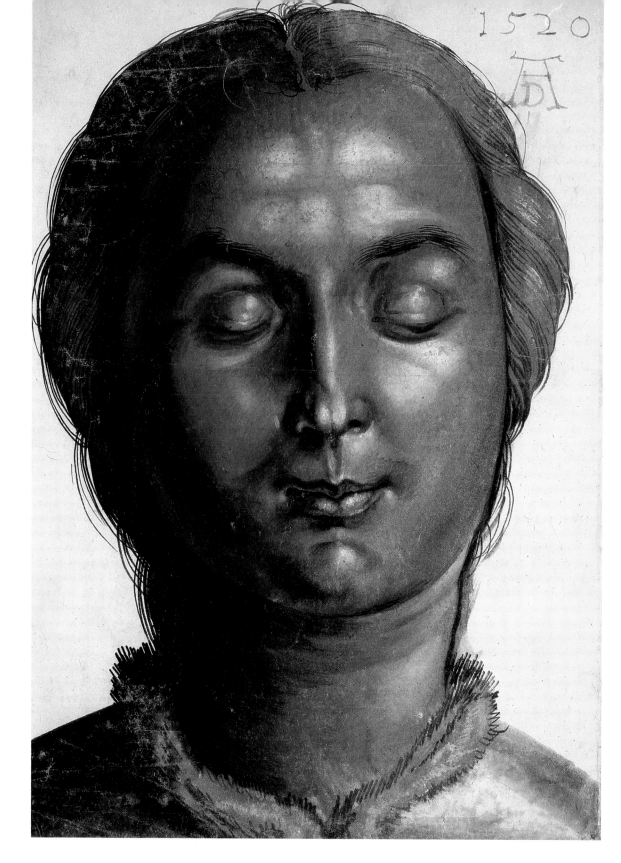

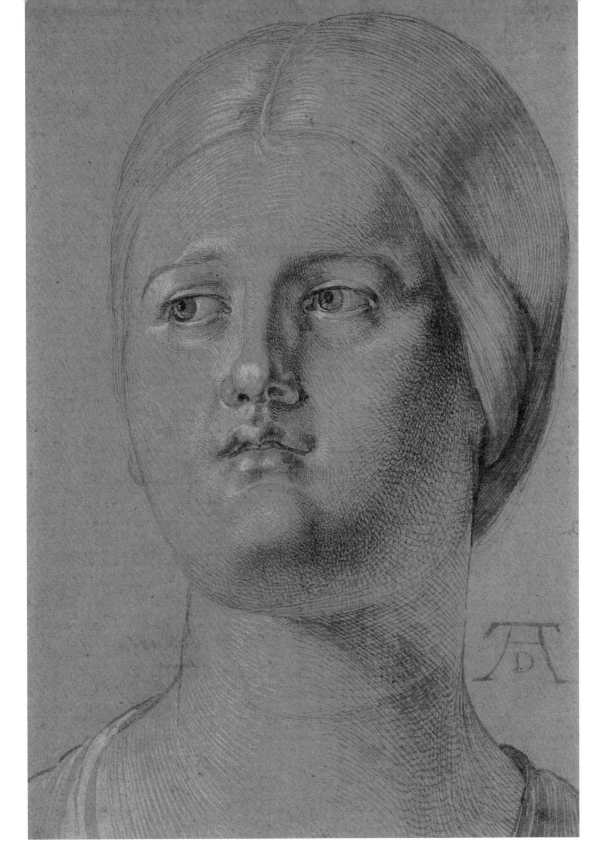

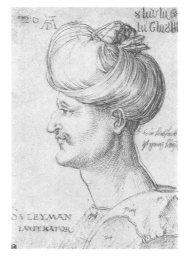

Sultan Suleiman, 1526. Silverpoint drawing, 18.4 x 13.3 cm. Bayonne, Musée Bonnat. (Monogram by Dürer.) Sultan Suleiman (the Magnificent; 1494–1566), who reigned from 1520, was one of the greatest rulers of the Ottoman Empire. In 1526, the year this likeness was taken, his many conquests took him as far as Hungary.

An Oriental Ruler on his Throne, c. 1495. Ink and Indian ink on paper, 30.6 x 19.7 cm. Washington, National Gallery of Art, Alisa Mellon Bruce Fund.

Western Europeans lived in fear of oriental rulers in the late Middle Ages. In 1529 the Turks laid siege to Vienna, threatening the very existence of occidental Christendom.

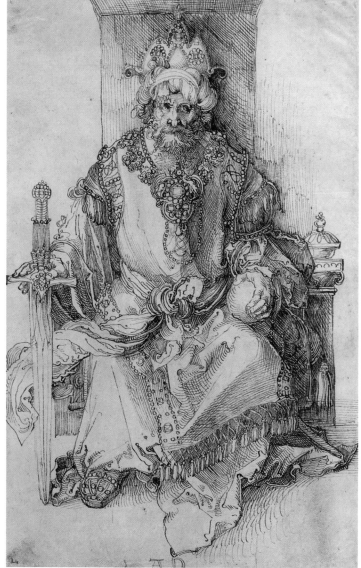

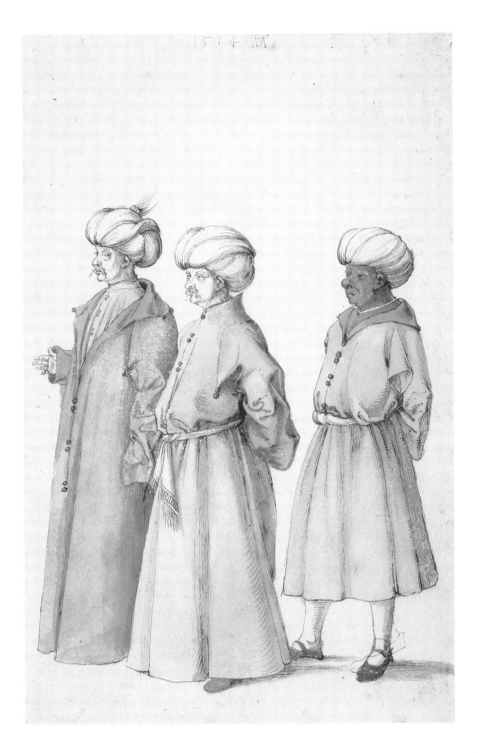

59

The Imperial Orb, undated. Ink drawing touched in with yellow watercolour, 27.3 x 21 cm. Nuremberg, Germanisches Nationalmuseum.

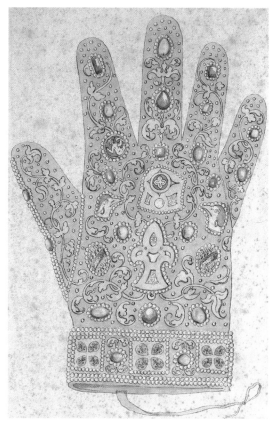

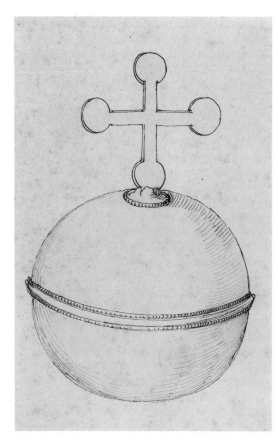

The Emperor's Glove, undated. Ink and watercolour, 30.5 x 19.8 cm. Budapest, Szépmüvészeti Múzeum, Praun and Esterházy Collection.

As preparation for a portrait of Charlemagne, Dürer studied the Holy Roman Empire's crown jewels and precious state apparel, kept in Nuremberg and put on public display every Easter. As well as the imperial sceptre and orb, the collection included an opulent glove.

The Imperial Crown, undated. Ink drawing touched in with watercolour, 23.7 x 28.1 cm. Nuremberg, Germanisches Nationalmuseum.

The crown of the Holy Roman Empire was also among the Nuremberg crown jewels. Though it was not in fact made until the coronation of Otto the Great in 962, in Dürer's imaginary portrait it is worn by Charlemagne (742/3–814).

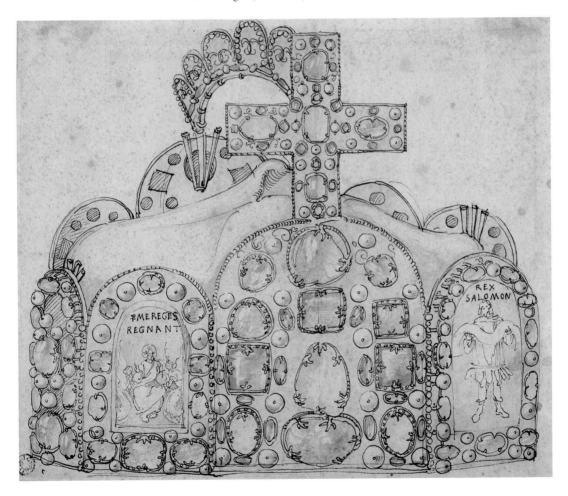

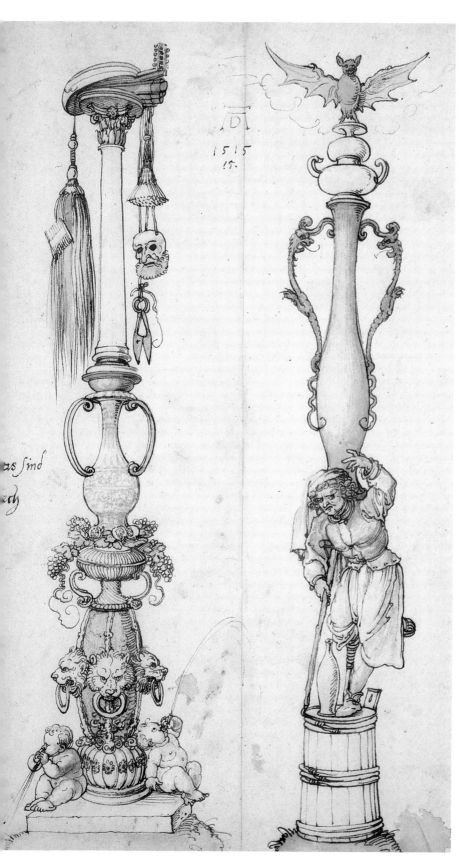

Two (Fantastic) Pillars, 1515. Ink drawing touched in with red, blue and brown watercolour, 20.3 x 14.3 cm. London, The British Museum. (Monogram by Dürer, date added by another hand.)

Opposite: *Design for a Table Fountain, 1509.* Ink drawing with colour ink wash, 30.5 x 19.4 cm. Oxford, Ashmolean Museum. (Monogram by Dürer, date added by another hand.)

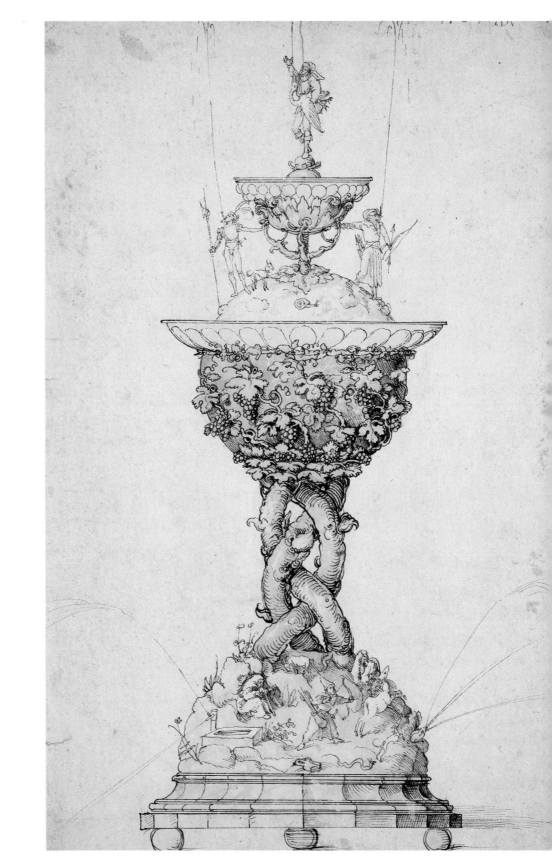

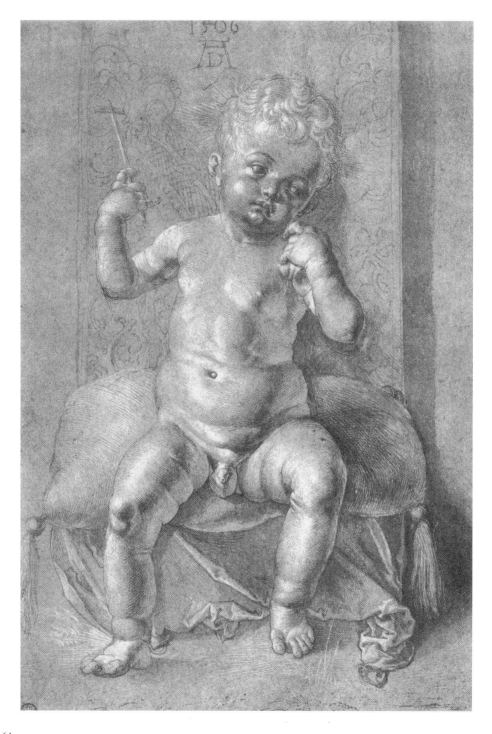

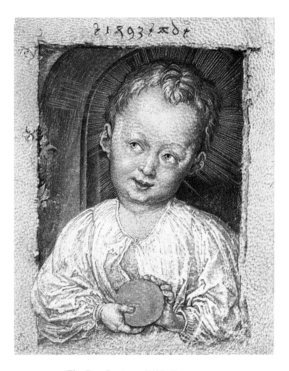

The Boy Saviour, 1493. Tempera on vellum, 11.8 x 9.3 cm. Vienna, Graphische Sammlung Albertina.

The Child Christ Enthroned, 1506. Study for *Madonna with the Siskin.* Brush drawing with white highlighting on blue Venetian paper, 39.6 x 27.2 cm. Lost (since 1945); formerly Bremen, Kunsthalle Bremen. (Monogram and date by Dürer). The differences between this study and the final painting indicate the importance Dürer assigned to preliminaries in their own right.

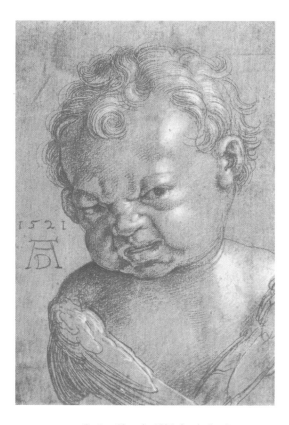

Crying Cherub, 1521. Study for the
painting *The Crucifixion*. Crayon
drawing with white highlighting on
blue primed paper, 21.1 x 16.7 cm.
Nuremberg, Germanisches National-
museum.

Child's Head Facing Right, undated.
Brush drawing with white high-
lighting on blue Venetian paper,
16 x 10.9 cm. Paris, Musée du
Louvre.

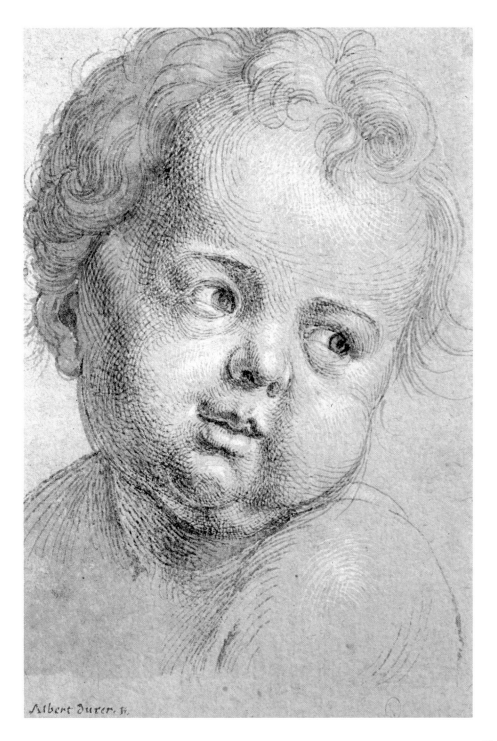

Albert Dürer. f.

Below left: *Mary Suckling the Infant on a Grassy Bank, undated.* Ink drawing, 11.7 x 7.8 cm. Vienna, Graphische Sammlung Albertina. (Monogram by another hand.)

Below right: *Mary in Nuremberg Traditional Costume, 1502.* Ink drawing, 19.9 x 12.8 cm. Oxford, Ashmolean Museum.

Small Head of Mary. Ink drawing, 4.2 x 4.2 cm. Hamburg, Hamburger Kunsthalle.

Opposite: *Mary Suckling the Infant, 1512.* Charcoal drawing, 41.8 x 28.8 cm. Vienna, Graphische Sammlung Albertina.

Mary as the giver of milk, the *galactrophusa*, is an age-old subject in Christian art. Dürer's is a worldly treatment of the subject; he has chosen to portray a woman of his own time, and has dispensed with the halo.

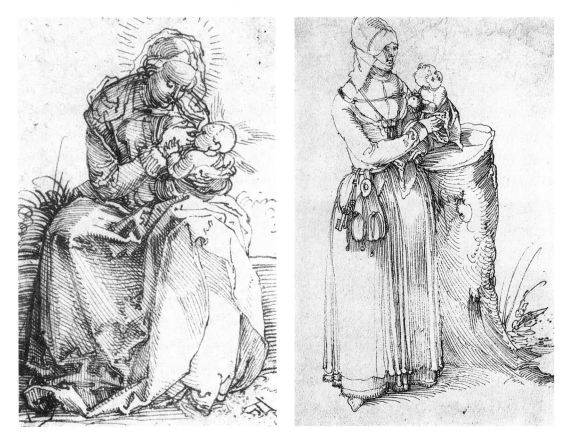

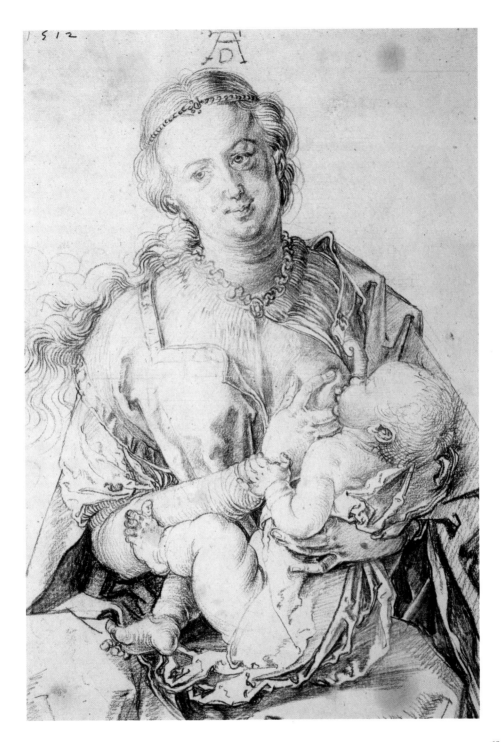

Opposite: *Adam and Eve (rear view), 1510.* Ink drawing, 29.5 x 22 cm. Vienna, Graphische Sammlung Albertina. (Monogram and date by Dürer.)

Temptation and seduction, personified here in the first two human beings on earth (in Christian teaching), gave Dürer an occasion to draw a scene of unusual intimacy, stripped to the essentials of erotic desire.

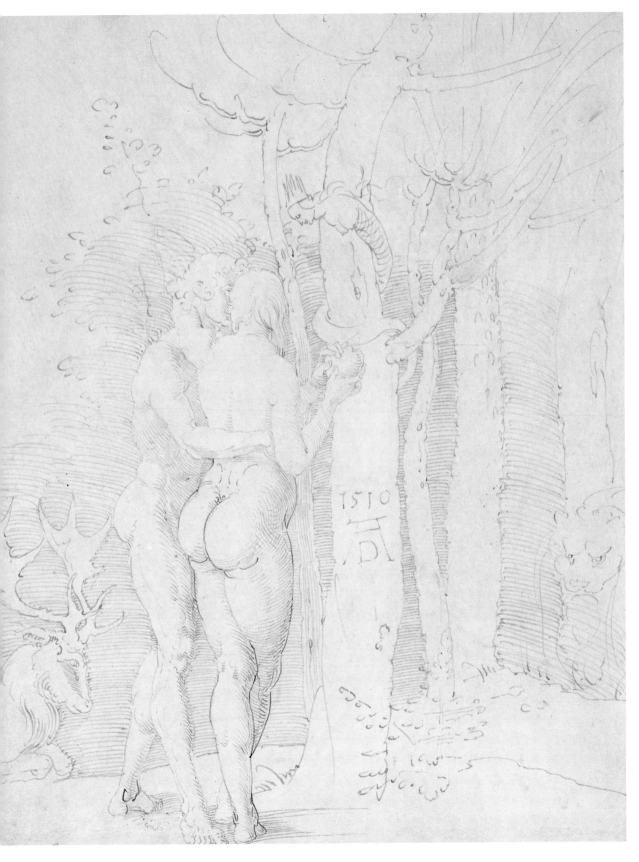

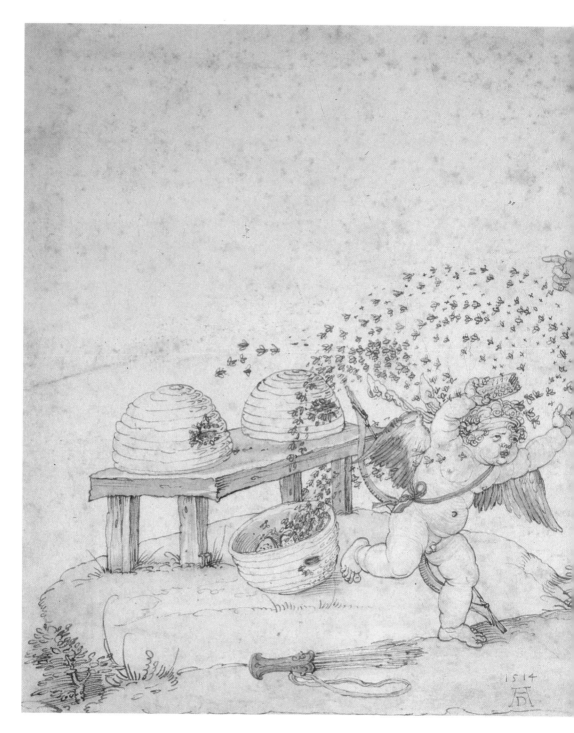

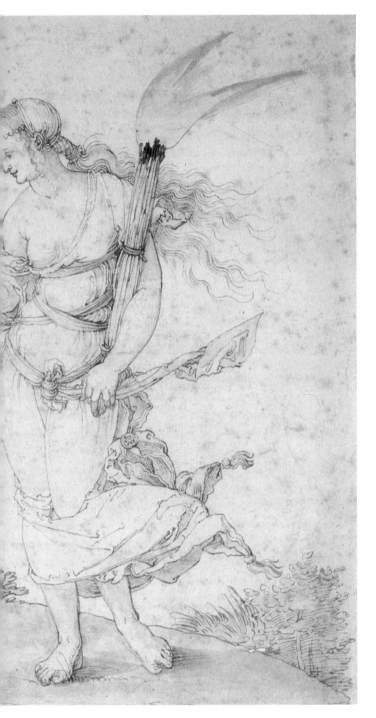

*Venus and Cupid, the Honey Thief,
1514.* Ink and brush study touched in
with watercolour, 21.6 x 31.3 cm.
Vienna, Kunsthistorisches Museum.
(Monogram and date by Dürer.)

Nude Man in a Circle and a Square, 1507.

Portrait of a Boy with a Long Beard, 1527. Watercolour on canvas, 55.2 x 27.8 cm. Paris, Musée du Louvre, Cabinet des Dessins. (Monogram and date by Dürer.)

The Ertlingen Siamese Twins, 1512.
Indian ink drawing, 15.8 x 20.8 cm.
Oxford, Ashmolean Museum.
(Monogram and date by Dürer.)

Like his elder contemporary Leonardo da Vinci, Dürer turned repeatedly to biological abnormality. This new kind of interest in the natural world produced this drawing of a malformed girl.

The Great Piece of Turf, 1503.
Watercolour and opaque,
41 x 31.5 cm. Vienna, Graphische
Sammlung Albertina.

This natural-size representation of
grasses, dandelion, pimpernel and
plantain was entirely new in art
when Dürer painted it in 1503.
Never before had anyone dared to
paint anything as insignificant as a
piece of turf. Dürer was later to ac-
count for his avant-garde sense of
the real in his *Four Books of Human
Proportions*: "Life in Nature reveals
the truth of things."

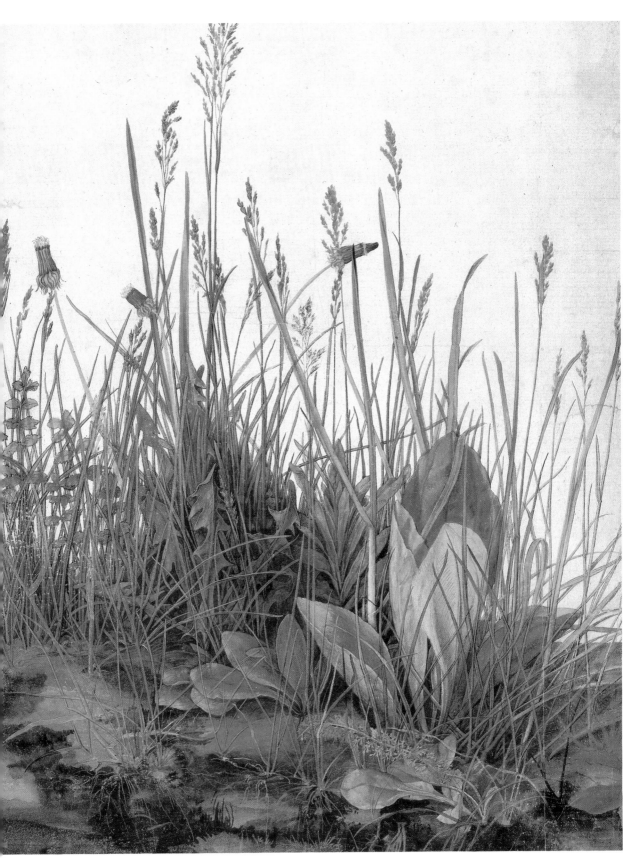

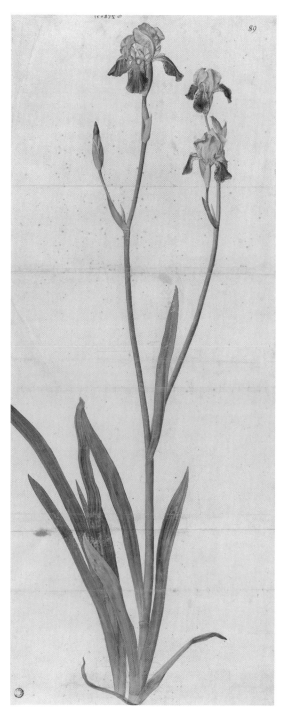

Iris (Iris troiana), 1508. Ink, watercolour and opaque on watermarked paper, 77.5 x 31.3 cm. Bremen, Kunsthalle Bremen. (Monogram by Dürer, dated by another hand.)

Plants, and particularly flowers, figured significantly as symbols in the Christian iconography of redemption in the age of Dürer. In paintings of saints and in altar pieces, flowers usually have a mystical meaning related to the Virgin Mary or Christ. Traditionally, the iris was symbolic of the forgiveness of sins.

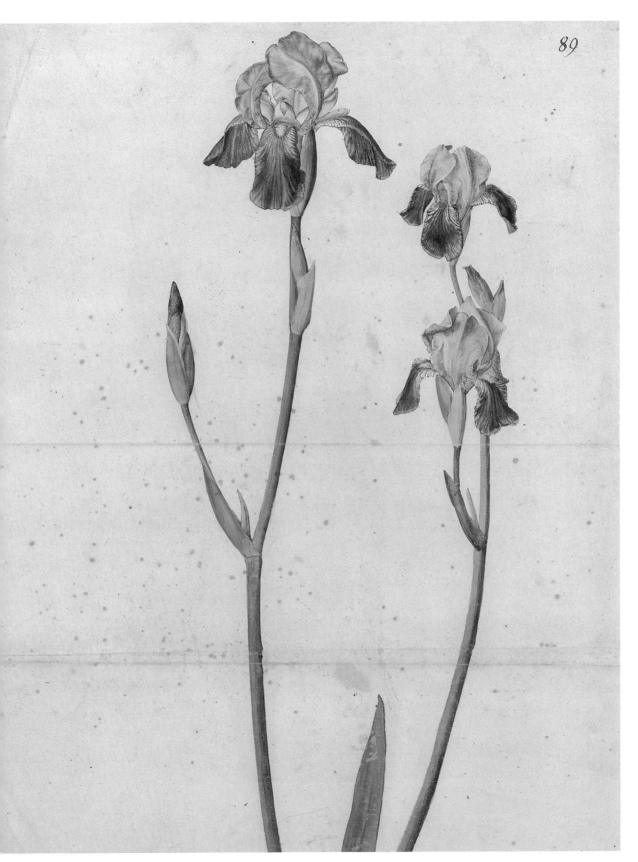

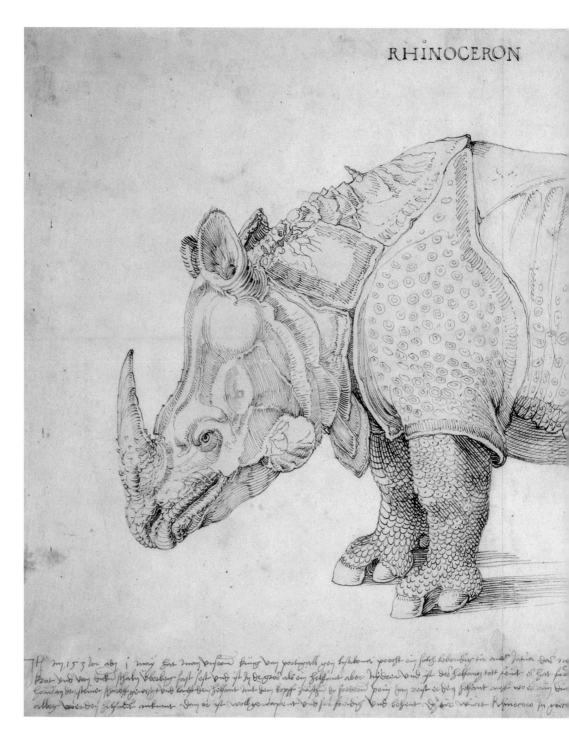

H͞ m 1513 Jor adj j may Sor man dnsorm kings say gostigoll say boblonov prast ein solos bebonsig tie uas India das m͞...

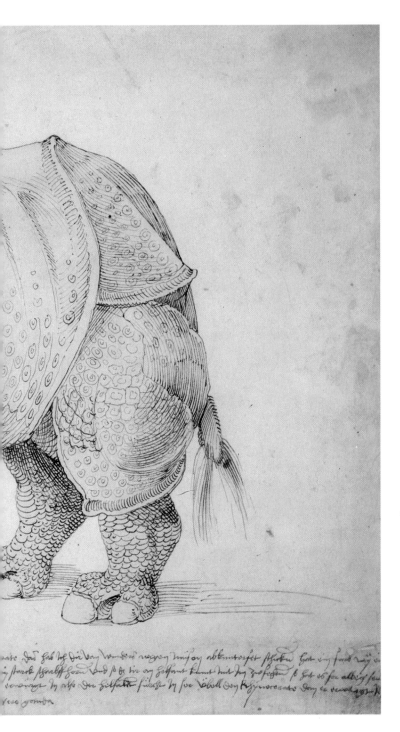

Rhinoceros, 1515. Ink drawing, 27.4 x 42 cm. London, The British Museum.

In 1515, King Manuel I of Portugal had an elephant and a rhinoceros brought to Lisbon as a gift for Pope Leo X. The ship carrying the rhinoceros sank, however, on its way to Italy, before the animal reached Rome. Dürer cannot have seen the rhino himself, but must have worked from reports and perhaps sketches by third parties – hence the anatomical anomalies in his version.

Head of a Roebuck, 1514. Brush watercolour drawing, 22.8 x 16.6 cm. Bayonne, Musée Bonnat. (Dürer's monogram, and date, probably by Hans Kulmbach.)

Dürer worked on his pictures of animals in three stages. First (as in this head of a roebuck) he brushed in the outlines. Then he coloured in the larger areas. Finally he brushed in the detailed work on fur and other finer areas.

Elk, c. 1519. Brush drawing, 21.3 x 26 cm. London, The British Museum.

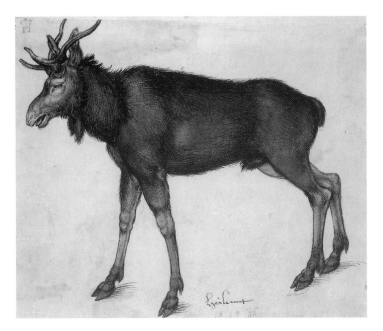

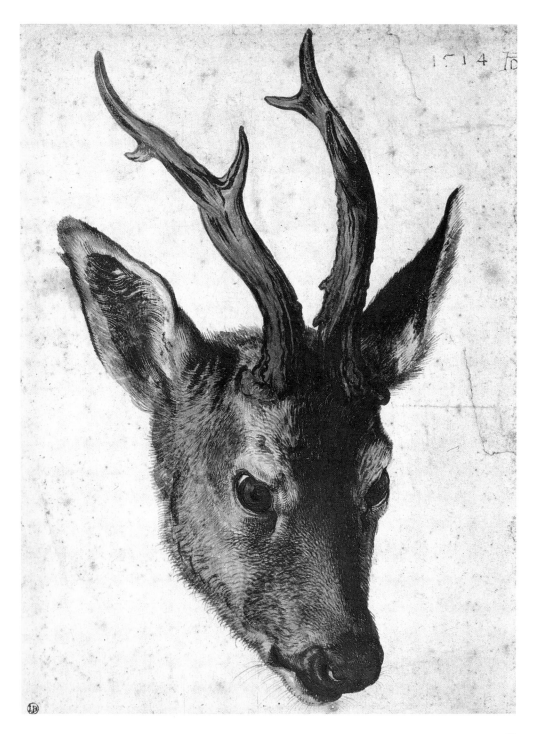

1514

Head of a Deer, with Monstrous Ant-lers, undated. Brown ink drawing, 24 x 30.9 cm. Berlin, Staatliche Museen zu Berlin – Preußischer Kulturbesitz, Kupferstichkabinett.

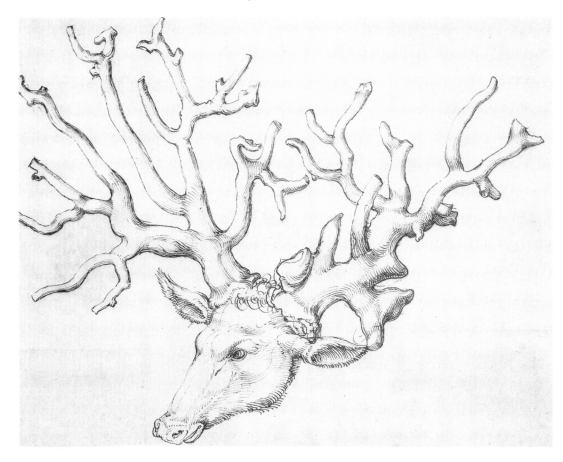

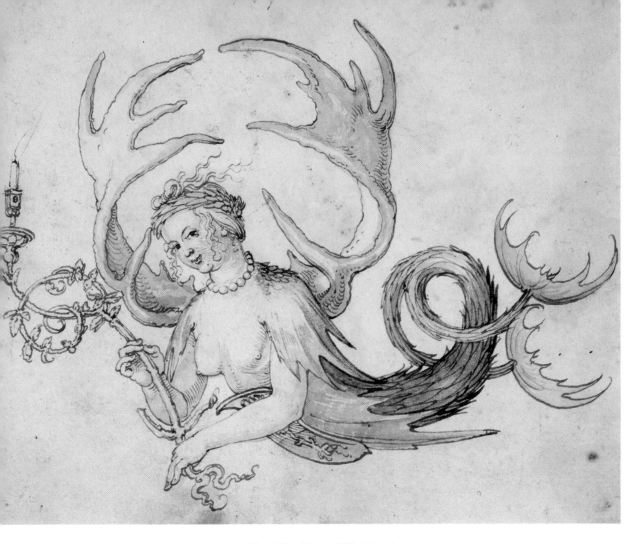

Chandelier Figure, 1513. Ink and
watercolour, 15.3 x 19.5 cm. Vienna,
Kunsthistorisches Museum.

Using a combination of antlers and
wooden figures for candlesticks and
chandeliers was fashionable in the
late Gothic. Dürer made a number of
these bizarre sculptures for his friend
Willibald Pirckheimer, among them
a nude woman with an elk's pal-
mated antlers.

Young Hare, 1502. Watercolour and opaque with white highlighting on paper, 25.1 x 22.6 cm. Vienna, Graphische Sammlung Albertina.

Dürer's scientific interests are particularly apparent in his pictures of animals and plant life. The precision of his technique conveys an impression of absolute faithfulness to Nature. Over a colour wash he painted the fur detail with a pointed brush, creating the illusion that he had painted every single hair on the hare's body, an illusion that doubtless led to this painting's extraordinary popularity.

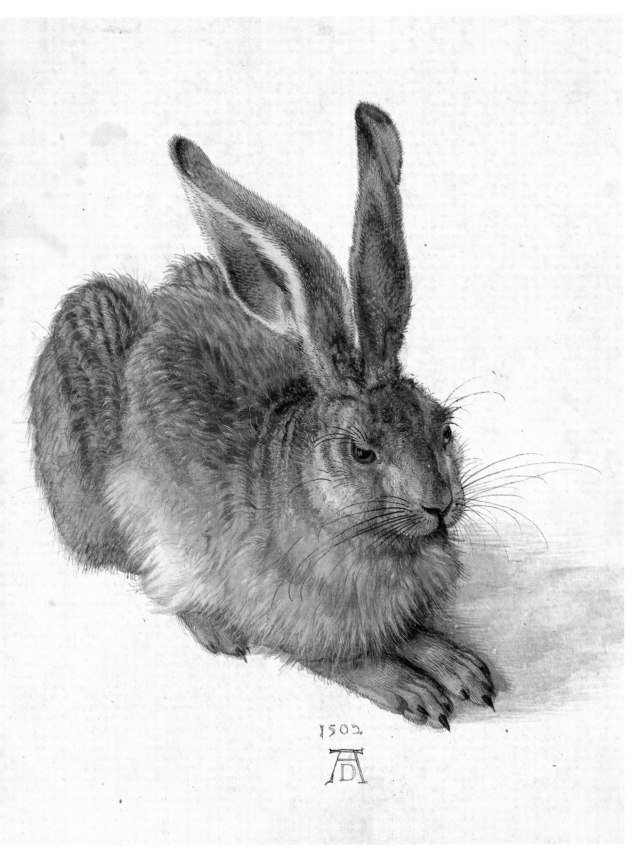

Wing of a Blue Roller (corracias gerula), 1512. Watercolour and opaque on parchment, 19.7 x 20 cm. Vienna, Graphische Sammlung Albertina.

Aged 41, Dürer was at the height of his powers and fame when he painted this bird's wing in 1512. His eye is as anatomically exact as a biologist's in his rendering of wing joints and the colours of the plumage. This may have served as a model for angels' wings in votive pictures.

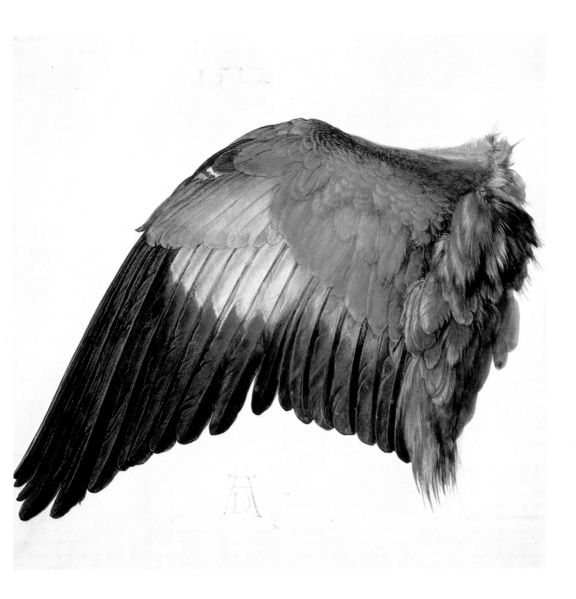

Muzzle of an Ox (frontal view), 1523. Brown, grey-black and pale pink watercolour, 19.7 x 15.8 cm. London, The British Museum. (Monogram and date by another hand.)

Head of a Walrus, 1521. Ink and brown Indian ink, 21.1 x 31.2 cm. London, The British Museum. (Monogram and date by Dürer.)

"The more accurately your work represents life, the better it will appear," was one of Dürer's key tenets. It accounts for his love of seemingly insignificant detail, apparent not only in his studies of plants and his portrait sketches but also, as here, in the muzzle of an ox, or the attempt at drawing a walrus.

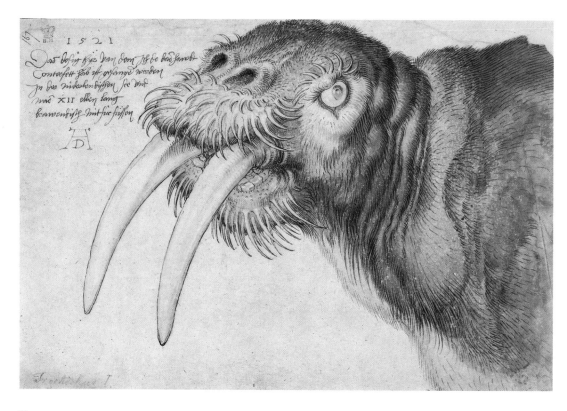

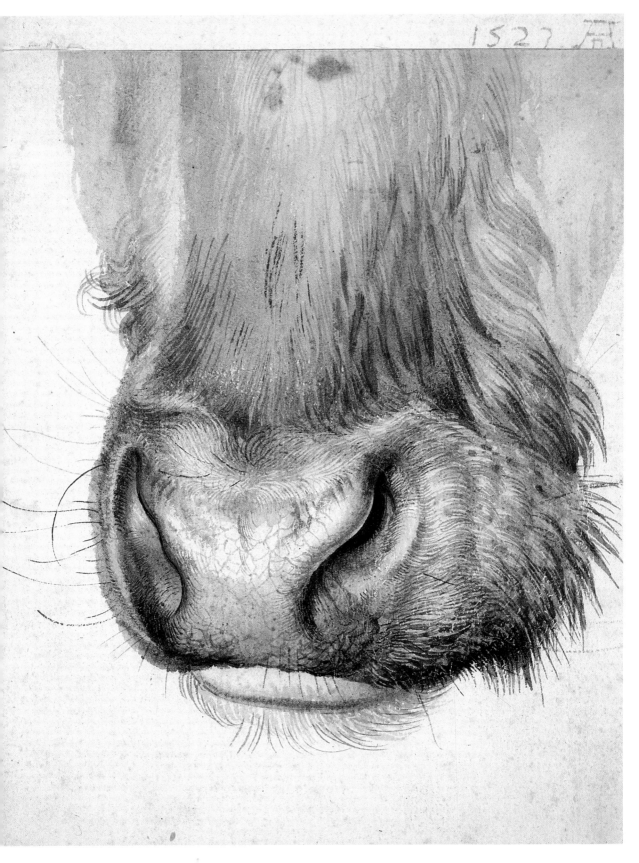

1527

Two Sketches for the Draughtsman with a Pot, undated. Ink drawing, 18.7 x 20.4 cm. Dresden, Sächsische Landesbibliothek.

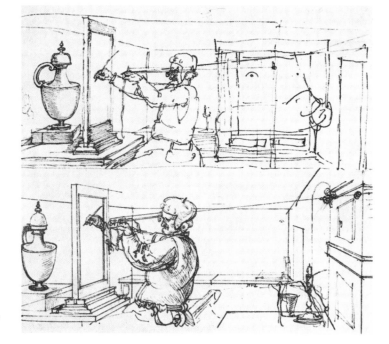

Dürer's Drawing Frame, 1515. Ink drawing, 12.2 x 17.4 cm. London, The British Museum.

Dürer used the drawing frame, invented in Italy, in order to reproduce things in precise perspective and represent them accurately to scale.

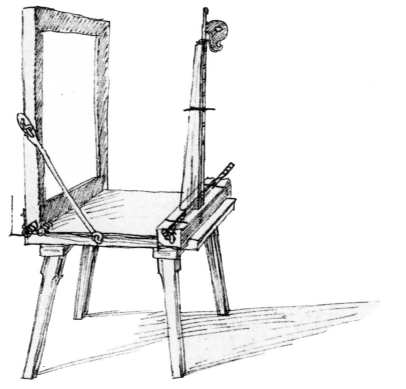

Portrait of a Master Builder, undated. Study for the painting *Adoration of the Virgin*, or, *Feast of Rose Garlands*. Brush drawing on blue Venetian paper, 38.6 x 26.3 cm. Berlin, Staatliche Museen zu Berlin – Preußischer Kulturbesitz, Kupferstichkabinett.

This lean-featured man holding a square is Hieronymus, a master builder of Nuremberg. Dürer drew the portrait as a preliminary study for *Adoration of the Virgin*, or, *Feast of Rose Garlands*, a painting which shows Mary and the boy Jesus distributing rose garlands to Pope Julius II, Emperor Maximilian, and prominent citizens of Nuremberg.

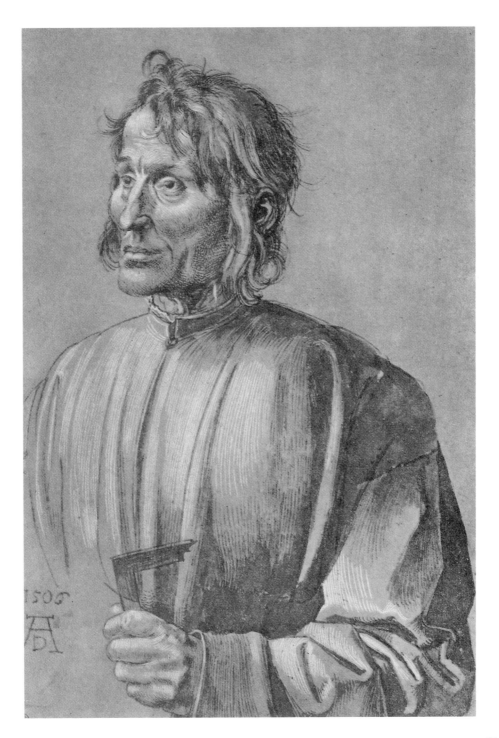

Albrecht Dürer 1471–1528: A Chronology

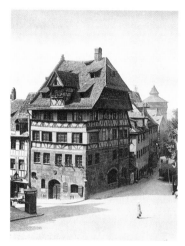

Dürer's house in Nuremberg, which he bought in 1509.

1471 Albrecht Dürer is born on 21 May, the third of 18 children of poor parents. His father, a goldsmith, moved to Nuremberg from Hungary. Albrecht is initially apprenticed to him.

1486 He is apprenticed to the Nuremberg master painter Michael Wolgemut.

1490 Dürer senior sends his son on his journeyman years, to Basle, Colmar and Strasburg.

1494 Dürer returns to Nuremberg and marries Agnes Frey, daughter of a wealthy merchant. Fleeing the plague, he travels to Italy, where he studies the work of the Renaissance masters, especially Andrea Mantegna.

1495 Dürer returns to Nuremberg and establishes his own woodcut workshop.

1498 He issues his *Apocalypse* series of woodcuts, which earns him immediate fame. He begins a lifelong friendship with Willibald Pirckheimer, Nuremberg humanist and imperial counsellor.

1505 Again Dürer flees the plague, travelling to Italy, where he visits Bologna, Florence and Rome but spends most of his time in Venice. He meets the Venetian aristocracy and familiarizes himself with the art of Leonardo and Raphael.

1507 Dürer returns home, painting famous landscape watercolours on his way.

1509 He buys an imposing residence in Nuremberg, now a Dürer museum, and is elected to the Grand Council of the city.

1512 Dürer works as a book illustrator for Holy Roman Emperor Maximilian.

1513/14 Three master engravings: *The Knight, Death and the Devil; St. Jerome in his Study*, and *Melancolia*.

1515 The Emperor awards Dürer an annual pension of 100 guldens.

1518 Dürer is a Nuremberg delegate at the Augsburg Imperial Diet (*Reichstag*), where he paints the portraits of a number of powerful men, including the wealthiest man of the age, Jakob Fugger the merchant.

1519 He paints several portraits of his patron, Maximilian, who died in January.

1520 In July, again fleeing the plague, he takes his wife and maid to the Netherlands, where he petitions for the continuance of his pension by Maximilian's successor, Charles V. He follows the young Emperor via Antwerp and Brussels to Cologne, till his wish is granted.

1521 Dürer and his wife spend the spring in Antwerp, where he studies Dutch art and is particularly impressed by Lucas van Leyden. His diary mentions the painting of twelve works. Soon thereafter he falls ill with malaria, from which he is to suffer for the rest of his life. In August he returns to Nuremberg.

1522 Dürer reacts sympathetically towards Luther and the Reformation.

1524 In the upheaval of the Reformation, five "godless painters" are put on trial in Nuremberg, among them Dürer's journeyman Jörg Pencz and his pupils Barthel and Sebald Beham, who are banished from the city.

1525 His woodcarver Hieronymus Andreae is arrested for his involvement in the Peasants' Revolt. Dürer publishes his treatise "The Teaching of Measurements".

1526 Dürer paints his *Four Apostles*, a late masterpiece.

1527 Writes "Fortifications of Towns, Castles and Places", a military treatise dedicated to the King of Bohemia, a brother of the Emperor.

1528 The "Four Books of Human Proportions" are published posthumously. Dürer dies on 6 April and is buried in St. John's churchyard. At the time of his death he is one of the hundred wealthiest citizens of Nuremberg, leaving his wife (the couple having remained childless) a fortune equivalent to about £100,000 in today's money.